THE DA VINCI
NOTEBOOKS

THE DA VINCI NOTEBOOKS

Leonardo da Vinci

EDITED AND WITH AN INTRODUCTION BY
EMMA DICKENS

ARCADE PUBLISHING

NEW YORK

FIRST NORTH AMERICAN EDITION 2006

First published in the U.K. by Profile Books, Ltd.

Library of Congress Cataloging-in-Publication Data

Leonardo, da Vinci, 1452–1519.
The Da Vinci notebooks / by Leonardo da Vinci. —1st North American ed.
p. cm.
Includes bibliographical references.
ISBN 1-55970-799-2 (alk. paper)
1. Leonardo, da Vinci, 1452–1519—Notebooks, sketchbooks, etc. 1. Title.

N6923.L33A35 2006

709.2—dc22 2005029288

Published in the United States by Arcade Publishing, Inc., New York
Distributed by Time Warner Book Group

Visit our Web site at www.arcadepub.com

10 9 8 7 6 5 4 3 2 1

EB

PRINTED IN THE UNITED STATES OF AMERICA

CONTENTS

✦

Introduction: The genius of da Vinci 1

1 *On his own writings* 33

2 *On painting in general* 37

3 *The perspective of disappearance* 41

4 *On the theory of colours* 43

5 *Aerial perspective* 47

6 *On the proportions and movements of the
human figure* 49

7 *Moral precepts for the student of painting* 59

8 *Judging a picture* 73

9 *On light and shade* 79

10 *Observing* 81

11 *Gestures and character* 85

12 *The artist's materials* 91

13 *Philosophy of the art of painting* 93

14 *Allegorical representations* 97

15 *Mottoes and emblems* 101

16 *Notes on sculpture* 105

17 *Observations on architecture* 111

18 *Anatomy* 119

19 *Man compared with animals* 131

20 *Physiology and medicine* 133

21 *On astronomy* 143

22 *Geography* 147

23 *Notes on the natural world* 155

24 *Machines and warfare* 159

25 *Number tricks* 167

26 *Philosophical maxims* 169

27 *Moral sayings* 175

28 *Polemics* 185

29 *Studies on the life and habits of animals* 197

30 *Fables* 203

31 *Jests and tales* 207

32 *Prophecies* 211

INTRODUCTION

The genius of Leonardo da Vinci

✠

Where to begin with Leonardo da Vinci? We have seen the list before: painter, sculptor, architect, inventor, anatomist. To that we might add botanist, zoologist, physicist, physical geographer, set designer, costume maker. Most recently we have heard his name in connection with Dan Brown's blockbuster novel *The Da Vinci Code*, in which da Vinci comes across as an intriguing, shadowy figure more interested in heading secret sects and writing codes than in the sometimes mundane business of making paintings.

In fact da Vinci is intriguing and shadowy partly because the fifteenth century is so far away – he was born more than five hundred and fifty years ago. His refined, sophisticated drawings make us claim him as a man of our times, but the life he knew was at the end of the medieval era. As this selection

of fascinating, varied and intriguing extracts from da Vinci's copious notebooks shows, he was a man who made things and showed us how to use them, rather than sharing his inner emotional life with us. Some of his writings here are detailed instructions or discussions – others are more hurried notes, and others again are downright cryptic and mysterious. This, too, contributes to the shadowy image we have of him. But the remarkable range of topics covered here is fascinating in itself. He was an old-fashioned grafter – famous for the phenomenal ways in which he applied himself.

It is inevitable that da Vinci should be described as a genius, but that label both puts him out of our reach and pins him down somehow. If we remember that he was just a man, then we can be properly astonished by his accomplishments; his intellectual and creative range can never cease to impress us. Just when we think we have got the hang of him, we find out that there is a sweetness there too: that he adored animals and was a vegetarian, that he was tremendously eager to please, but that he was no pushover. He was serious but playful – he loved punning. We learn that he had something of a reputation for unreliability, but that he inspired devotion in the King of France. In his sheer humanity, his

human-ness, he is terrifying. By freeing him of the dehumanising label of 'genius', we are able to realise that he embodies the potential scope of a human being. He makes us confront what we have the potential to be.

Early life

'1452. There was born to me a grandson, the son of Ser Piero my son, on the 15 day of April, a Saturday, at the third hour of the night. He bears the name Lionardo.'

So reads a momentous entry in the notebook of Leonardo da Vinci's grandfather Antonio. According to Charles Nicholl in his wonderful recent biography *Leonardo Da Vinci – The Flights of the Mind*, the event is likely to have occurred in the small hamlet of Anchiano, around two miles from Vinci in Tuscany, Italy.

Antonio and his son were both notaries, professional keepers of business records. Leonardo's mother, Caterina, who was not married to Ser Piero, has always been portrayed as a serving girl, although one of her son's early biographers described her as being 'of good blood'. Not good enough for the

ambitious da Vinci family, however. Within a year Leonardo's parents were both married to other people: Ser Piero to Albiera, a rich notary's daughter; Caterina to Accattabriga, a furnace worker.

That Leonardo was a 'love child' does not seem to have counted against him initially. At his christening, ten godparents greeted his arrival. Then he probably moved with his mother and her husband to Campo Zeppi, the Accattabrigas' patch just west of Vinci. Although Ser Piero appears to have been something of an absent father, Leonardo was devoted to his uncle Francesco, who was only fifteen when he was born and was cut from softer cloth than many of the da Vincis. Leonardo's mother went on to have five more children.

As a child Leonardo immersed himself in the countryside. He loved animals and had an enquiring mind from the outset. Giorgio Vasari, the sixteenth-century artist and biographer, portrays him as a brilliant pupil with flamboyant 'mirror' handwriting who often stumped his teacher and had a restless mind – constantly picking up subjects only to drop them again. The writing went on to change later in his life to a more sober and workmanlike hand, but he always wrote in mirror script – in all likeli-

hood because he was left-handed and it was easier for him.

He also had troubling dreams. Puzzlingly, his earliest memory was of a kite flying into his crib and putting its tail between his lips. Surely this is one of those vivid dreams which persist in the memory more clearly than real events.

Florence (1466–82)

And he always drew and sculpted. So his father, sensing that he would not make a notary of his teenage son, showed some of the boy's sketches to his friend Andrea del Verrocchio, a Florentine sculptor. Verrocchio was immediately struck by the work and offered him an apprenticeship. He took this up in 1467, at the age of fifteen.

The Florence that greeted Leonardo was in a state of flux: ostentatious buildings were replacing unremarkable medieval architecture; the mighty Medici dynasty ruled the roost, challenged by rivals at regular intervals. Yet for all their cultivation and patronage, it was not the Medicis that first turned Leonardo's head, but Leon Battista Alberti, a graceful, stylish polymath – who was among other things an

architect, scholar, set designer and town planner.

But despite the distractions of Florence and its leading figures, there was work to be done back at Verrocchio's studio or 'bottega'. Training an apprentice was a serious, formal business. At first the emphasis would have been on draughtsmanship. Verrocchio himself was an accomplished draughtsman who would have given Leonardo an appreciation of perspective and texture by overseeing his studies of drapery and flowers and his clay modelling.

The maestro's protégés doubled as models, and there is some speculation that new arrival Leonardo posed for Verrocchio's beautiful bronze *David* of 1466. There is also speculation that Verrocchio launched Leonardo on the path to his now widely accepted homosexuality, although Vasari says that Verrocchio 'loved' another of his pupils, Lorenzo di Credi, the most.

Once Verrocchio's pupils were judged to be competent draughtsmen, the painting could begin – at first using traditional 'tempura' paints (colours mixed with egg white) and then moving on to work with the new-fangled oil paints, which Leonardo seized with an enthusiasm that he never lost. Around 1468–70 Verrocchio's bottega turned out a small painting called *Tobias and the Angel*, and

art historians agree that the small dog and fish that appear in it are by the hand of a young Leonardo da Vinci. By the early 1470s, at about the age of twenty, it is thought that he was producing work of the calibre of the *Madonna of the Carnation*, which certainly came out of Verrocchio's studio.

In addition, Verrocchio and his entourage would have been hired by the Medicis to design and make all sorts of props for the flamboyant pageants that were a regular feature of Florentine life. The impact that such theatricality had on Leonardo became clear years later. He also had an early brush with architecture when Verrocchio was hired to complete the cathedral by putting an orb on the top of the dome.

Meanwhile, Leonardo's relationship with his father seems to have been patchy and difficult. Then, in 1475, his father married for a third time and had a legitimate son, which meant that Leonardo was disinherited. At around the same time, melancholic little phrases about wasting time and losing friends begin to appear on his drawings. He is fired up, he seems to be saying, but has not yet found love.

Or has he? In 1476, via an anonymous note posted in the system of 'drums' which were placed around the city in order to collect information and

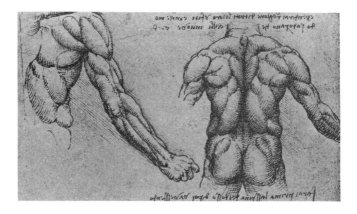

keep tabs on its citizens, a set of scandalous charges was levelled against four men, one of whom was Leonardo da Vinci. It was claimed that seventeen-year-old Jacopo Saltarelli, who 'pursues many immoral activities and consents to satisfy those persons who request such sinful things from him', had been sodomised by all four men at different times. The anonymous note did not say whether or not he was paid for this service.

Although Saltarelli may have been paid to model for Leonardo, an activity which in no way precludes sodomy, we do not know for sure about Leonardo's sexuality. We do know that he painted sexy pictures of young men and we suspect he was gay, but the nameless gossip's charges were dropped eventually

and Leonardo was judged to be 'above suspicion'.

Leonardo's artistic talent was beyond question. Vasari's story is that the angel contributed by Leonardo to Verrocchio's *Baptism of Christ* was so much better than the rest of the painting that the master was overwhelmed and gave up painting, but it was an early work, and Charles Nicholl for one doesn't think it that good. Certainly the story itself has an over-egged, apocryphal feel to it.

And Vasari in no sense under-eggs his physical description of Leonardo either. He is like a schoolgirl with a crush. It is generally accepted that Leonardo was a very beautiful man, but Vasari saw him as the possessor of 'infinite grace' at the same time as being 'so strong he could withstand any violence'. Leonardo was also quite particular about his appearance, and was a sharp dresser. His boots were made of the finest leather; he wore a rose-coloured tunic.

Not long after the legitimate son of Ser Piero was born, Leonardo set up shop on his own. One of the pupils he took on was even more controversial than he. Paolo had actually done time – six months in prison – for his 'wicked life', which probably meant 'homosexuality'. Another of Leonardo's number was Zoroastro, an exotic servant cum colour grinder

cum alchemist, who remained a loyal support and friend for the rest of his life.

As far as is known, the first commission worked on by Leonardo's studio was an altarpiece, commissioned on 10 January 1478, when Leonardo was twenty-five. Other paintings started to show the fondness for rocky, wild landscape which his later, more famous work displayed, and one of his trademark animals makes an appearance in *Virgin and Child with a Cat* (1478–81). He was also starting to make technological drawings and to show an interest in water and in flying machines. Later in 1478 he sketched the hanged Bernardo di Bandino, who had dared to stab Giuliano Medici. Leonardo may have been pitching for work from the Medicis at the time.

It looks as if Leonardo is establishing himself in a reasonably conventional way. He is an artist of note building up a client base of Florentine patrons. He has outside interests, but they all seem to relate in some way to his art. Yet just as it seems we are pinning him down, he slips out of our grasp – he leaves Florence for Milan. And what does he introduce himself as when he arrives there? As a musician.

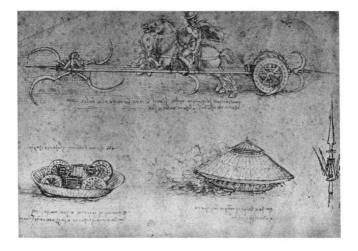

Milan (1482–99)

For some time Leonardo had been hatching a plot to become engineer to Ludovico Sforza, the Duke of Milan. Sforza was a terrifying and warlike man, and Leonardo thought he could help him in a martial capacity, but he had done his research and found out that Sforza was also a great lover of lyre music – and Leonardo was a brilliant lyre player. He was going to seduce the duke into hiring him.

The plan appears to have worked. Before too long, he was making drawings of armoured vehicles and foundries for the duke, some of them actually

useful. He began taking commissions for paintings, often working with other local artists. *Virgin of the Rocks* was embarked on in 1485. At around the same time he painted *Lady with an Ermine*, his enigmatic portrait of Cecilia Gallerine, who was probably the duke's mistress.

And the obsessive notebook writing began in earnest, partly in an attempt to make himself indispensable to the duke. Although on a practical level this campaign was undertaken to earn a living, there was surely also somewhere in there the keenness to please of a boy with a remote father. The vast scope of Leonardo's notebooks is legendary. In them he scribbled all manner of inventions, observations on architecture, studies in anatomy.

Leonardo faced anatomy head-on, through the modern and controversial technique of postmortem examination. The anatomist in him is there for all to see in many of his drawings, but it is perhaps most famously realised – along with his interests in geometry and architecture – in *The Vitruvian Man* (1490), shown overleaf, which may or may not be a self-portrait, and which explores the ideas of harmonious proportion first examined by the first-century architect and military engineer Vitruvius.

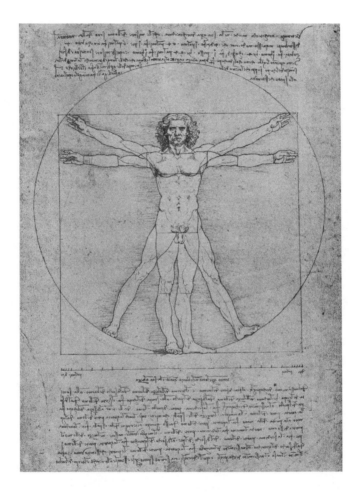

Leonardo's childhood passions were also allowed to come to the fore from time to time. In the summer of 1489, he was commissioned by Sforza to make a mighty, awe-inspiring bronze of a horse as a monument to the duke's father. Leonardo was a horse aficionado and made many beautiful equine drawings, but he was getting a reputation for being unreliable too, and the duke was not convinced that he would pull the project off. Ultimately it failed because the bronze assigned to the sculpture was used to make three cannon, but Sforza must have been worried by Leonardo's ambition from the outset. For structural reasons horses had always been depicted trotting – Leonardo was determined to make one that reared.

In 1489, he was able to indulge his theatrical side by providing stage sets and fantastical grotesque masks for the wedding celebrations of Sforza's nephew, Duke Gian Galeazzo. Leonardo's assistant Boltraffo made a beautiful drawing of Galeazzo's wife, Isabella of Aragon.

Of less help was a naughty ten-year-old boy who arrived at about this time. His name was Giacomo – although he was better known by his nickname Salai, or 'little imp' – and he was from Oreno, just north of Milan. He was hired to help around the

studio with a view to being trained up as a painter when he was older, and he immediately set about filling his days by stealing from people and cutting up their clothes. Leonardo loved and was exasperated by Salai in equal measure. By the time the boy was in his teens, they were almost certainly lovers.

The next period was a restless one, involving a fair amount of travelling around the Alps. Then, from nowhere, we learn that someone called Caterina arrived. Although his notebooks record the event in the starkest and briefest terms possible, this must surely have been his mother. Maxims appear in his notebook that seem to betray confusion over long-buried feelings: 'In some animals Nature seems a cruel stepmother rather than a mother; and in others not a stepmother but a tender mother' and 'Do not be a liar about the past' are among them.

In 1495, work began on Leonardo's second-best-known work, *The Last Supper*. How important the painting was to him is clear from a letter he drafted to the duke complaining of how 'vexed' he was at having been taken off it to work on 'lesser matters'. It was probably taking him ages. He and his team worked on it using a new technique which allowed him to paint more slowly than did the traditional method, but which, it soon emerged, flaked off.

The upshot of this was that over the centuries artists tried to 'help' the painting, further obscuring the work of the master.

Rare respite from all the pressure came in 1497, when the duke gave Leonardo a big garden, which he came to love. But by 1499, French troops had begun gathering on Italy's borders and Leonardo started to think about moving on again. Soon Sforza had fled and the artist was in need of a new patron.

Back to Florence (1500–1508)

Another period of moving around followed, which began in Mantua, where Leonardo stopped off to see Sforza's beautiful and formidable sister-in-law Isabella D'Este. He drew her – with the folded hands of the Mona Lisa. Then he went to Venice, where he advised the Venetian senate about the potential fortification of the Isonzo river and learned about printing. He also learned that Sforza had been captured by the French – eight years later, the duke died in captivity.

Back in Florence things were familiar, of course, yet changed. Artists he had admired had started to

die. The Medicis had been toppled six years earlier, and for all their unsavoury habits they had at least cultivated the place. The fire-and-brimstone friar who replaced them, Girolamo Savonarola, preached moral purification and practised the active destruction of artworks. And the republican government was in a war against Pisa, for which it needed Leonardo's military skills.

Leonardo was clearly in demand for his painting, too. In 1501 another friar, Fra Pietro Novellara, sent him a message to say that Isabella D'Este wanted more of his work. On the whole, what Isabella wanted, Isabella got – but not on this occasion. She would have to wait, the poor friar reported back, as Leonardo was working on an altarpiece and his life was 'extremely irregular and haphazard … he seems to live from day to day'.

For all her demands and acquisitiveness, Isabella would have made a good and sympathetic patron, but Leonardo wanted to catch a far bigger and more slippery fish – someone who was equally acquisitive, but for land and power. By 1502, he was in the service of Cesare Borgia – the model for Machiavelli's Prince.

Borgia had taken over a number of disparate Italian communities in the middle of Italy and then

appointed himself the 'Duke of Romagna'. One of these communities was Imola, which was among the small towns that Leonardo almost immediately began to visit in a consultative capacity, advising on engineering projects. He designed bridges and talked about changing the course of the Arno river.

He also met a young, unknown writer called Niccolò Machiavelli. Unlike his new friend Machiavelli, Leonardo was not full of admiration for his power-crazed, warmongering patron. Despite his hand in designing the machinery of war, Leonardo was of a peaceful sensibility. So while Borgia ravaged the land and its people and Machiavelli took notes, Leonardo went some way towards squaring the situation with himself by taking a wilfully innocent route, observing simple things: the topography, the mechanism of a church bell. In the words of Charles Nicholl, 'He is looking the other way.' And Borgia is not unstoppable, as it turns out. When his father dies, he loses power, and it is time for Leonardo and his people – among them Zoroastro the colour grinder and naughty Salai – to clear off again.

Soon after this, work began on Leonardo's most famous work of all, the *Mona Lisa* – or, more properly, *La Gioconda*, or 'Jocund woman', since *Mona Lisa* as a title did not come into use until

the nineteenth century. This celebrated painting was the culmination of several interesting aspects of his work, and despite more salacious rumours to the contrary – because of her mischievous smile we have always wanted her to have a story to match – it was probably a simple commission from the Florentine merchant Francesco del Giocondo as a record of his wife, Lisa.

Machiavelli was not the only superstar in the making who came into contact with our hero during this time: it sometimes felt to Leonardo da Vinci and Michelangelo Buonarroti that the town of Florence just wasn't big enough for the two of them. Leonardo attempted – unsuccessfully – to get Michelangelo's *David* put in a less prominent position than the main entrance to the Palazzo Vecchio; Michelangelo preferred a more direct mode of attack, taunting Leonardo over the failure of his bronze horse.

In July 1504, Leonardo's father, Ser Piero, died, and again he recorded the occasion in a note of heart-breaking brevity, this time as part of a list. Whatever his feelings – liberation? loss? regret? – the event had a nasty sting in its tail: Leonardo had been cut out of the will. Perhaps by now Leonardo did not need the money, but we can glean from his con-

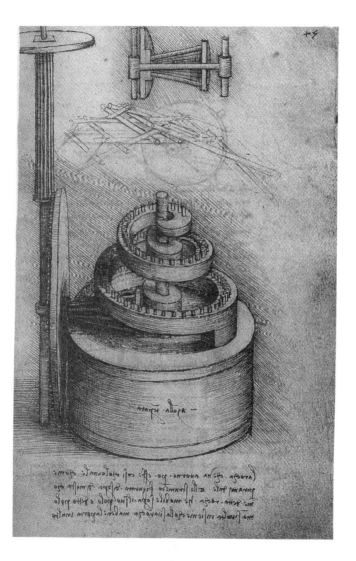

tinuing search for approval that he would not have minded the recognition.

In December he began work on the violent scenes of the *Battle of Anghiari* fresco. Perhaps the experience was cathartic after his father's death and after all that bloodshed at the hands of his patrons Sforza and Borgia. He was also thinking about birds and flying machines more than ever before. In this he had no more notion of himself as the archetypal Renaissance man than he'd had when dreaming of kites in cribs five decades earlier. It was just that he wanted to fly away.

And to Milan again (1505–13)

In 1505 Leonardo had the French who were based in Milan screaming at him in one ear and the Florentines in the other. The Cofraternity of the Immaculate Conception who in 1485 had commissioned the *Virgin of the Rocks* – which was painted in partnership with Ambrogio de Predis – were unhappy with the work, and the two artists were squabbling over the greatly reduced fee. The dispute rumbled on for a total of 25 years. Meanwhile, Leonardo was

under pressure from Florence to finish the *Anghiari* fresco.

There was still time to find a French patron, though, and this came in the form of Charles d'Amboise, the French governor of Milan. Leonardo was helping him to design a summer villa, and the enthusiasm of his writing suggests that this time his old eagerness to please was being rewarded – finally he was attracting the kind of sympathetic patron he deserved. And reverting to type he found solace in a garden – albeit one in his mind at that stage. His descriptions of the garden tailor-made to suit Amboise are wonderful. There should be orange and lemon trees, he said, songbirds and fish – but not the type that eat other fish, like eel or tench or pike. Not, one senses, like the ones he might have chosen for Sforza or Borgia.

Neither the artist nor his patron wanted him to return to Florence to finish the *Battle of Anghiari*, so it was delayed. In 1507, he took on a kind of personal assistant called Francesco Melzi, who was young and very handsome. They became lovers – presumably Salai felt the force of something being stolen from him, for a change – and Melzi turned out to be a talented artist, but he was probably appointed mainly because Leonardo was getting older and

starting to become preoccupied with putting his affairs – or rather his many, many notebooks – in order. Melzi did this after Leonardo's death.

He gained Melzi, but he lost his beloved uncle Francesco. And Francesco, probably in response to his brother Ser Piero cutting Leonardo out of his will, left his nephew everything. Leonardo's half-brothers were incensed – the battle of the gentle country da Vincis, one of them fighting from beyond the grave, and the grasping city da Vincis ensued. But the country boy had power these days and his half-brothers got nowhere.

Leonardo's increasing fear of organising all his written material did not stop him adding to it. He became particularly preoccupied, as he grew older, with matters of life and death: with fossils, dissections of old men and drawings of embryos. He also wrote mottoes for refined men and women to ruminate over. And he continued to write about geometry and, as ever, flying machines. In a discussion about water he interrupts himself, imploring the reader – presumably Melzi in the first instance – not to laugh at him for jumping from subject to subject. Leonardo da Vinci is beginning to wonder what his life amounts to; he fears it might be nothing more than a hill of notebooks.

There were many unfinished paintings too, but if those concerned him he did not say so. He was still painting a lot, often in his characteristic and unique *sfumato* style, which gently blended the tones in his pictures into one another to avoid any harsh contours. He was unable to do anything about life's harsh contours, though. In 1511 Charles d'Amboise died, aged forty.

Leonardo was by now sixty, and the general consensus is that the famous red chalk drawing of him in profile was made by Melzi at about this time. It is an exquisite and perhaps a loving work portraying a handsome, gentle, sympathetic thinker. In it, whoever drew it betrays his admiration for the sitter.

Rome (1513–19)

Eventually, on 24 September 1513, Leonardo and his entourage left Milan after a three-month stay that had turned into seven years. They were bound for Rome, where the Medicis were in favour again. Giuliano de' Medici was not particularly ambitious or aggressively political like his father Lorenzo or his brother Giovanni, who was about to become Pope Leo X. He was a dreamer and fancied himself

a scholar – and he had requested the pleasure of the company of Leonardo da Vinci.

Artists like Michelangelo and Raphael were also working in Rome at that time and soon Leonardo joined them, undertaking commissions for the Medicis and others. The pope sometimes despaired of Leonardo's working methods, perhaps because he had a tendency not to finish work, but his brother Giuliano began to see Leonardo as more of a brother than a friend.

Leonardo made pictures of John the Baptist and at some point the mysterious *Angelo Incarnato* or 'Sick Bacchus', with its breasts and proud erection, but on the whole his thoughts were turning to the mighty and the elemental, to the force of Nature. He was learning to draw tempests and exploring his interest in solar power.

He was also ill. His right hand had, we are told, been 'paralysed' for some time. He may have had some kind of stroke. Leonardo had always been wary of doctors: his response was to take the commonsense advice of medieval folklore; he copied a poem into his book which advised chewing food, avoiding stuffy air and remaining cheerful. By now he was certainly a vegetarian – a very rare creature indeed in sixteenth-century Italy.

There is the faintest whiff of Leonardo becoming devout at around this time – he enrolled in the Confraternity of St John of the Florentines. His membership soon lapsed, however, when he failed to pay his dues, but why did he join in the first place? It may have been to get a decent burial, or perhaps it was a speculative attempt to ingratiate himself with the last and greatest patron of all – the one in the sky.

Giuliano died of consumption in 1516, at the age of only 37, and Leonardo's assorted services became in demand by the King of France, François I. Happily the king became devoted to him, just as his last two patrons had been – François was awestruck by his talents. According to the sculptor Benvenuto Cellini, 'there were few days in the year when [the king] was parted from him'.

François I put Leonardo up in a big manor house called Cloux in the Auvergne and had a party in its garden in his honour. As well as becoming something of a human tourist attraction, Leonardo helped with designs for this party and for other parties and masques. Presumably Salai and Melzi were not far away, although Charles Nicholl thinks it is possible that Salai was spying on the King of France for the Duke of Milan – certainly he was in his pay.

Leonardo da Vinci's death, on 2 May 1519, was a quieter affair than legend would have it. Victorian paintings depict a distraught King of France holding him in his arms, but record places the king elsewhere at the time of Leonardo's death. Charles Nicholl is sure that Melzi would have been there, though – in tears and inconsolable.

THE NOTEBOOKS

I

On his own writings

❖

Let no man who is not a Mathematician read the elements of my work.

∿

The Book of the science of Mechanics must precede the Book of useful inventions. – Have your books on anatomy bound!

∿

Seeing that I can find no subject specially useful or pleasing – since the men who have come before me have taken for their own every useful or necessary theme – I must do like one who, being poor, comes last to the fair, and can find no other way of providing himself than by taking all the things already seen by other buyers, and not taken but refused by reason of their lesser value. I, then, will load my humble

pack with this despised and rejected merchandise, the refuse of so many buyers, and will go about to distribute it, not indeed in great cities, but in the poorer towns, taking such a price as the wares I offer may be worth.

∾

I know that many will call this useless work, and they will be those of whom Demetrius declared that he took no more account of the wind that came out their mouth in words, than of that they expelled from their lower parts: men who desire nothing but material riches and are absolutely devoid of that of wisdom, which is the food and the only true riches of the mind. For so much more worthy as the soul is than the body. And often, when I see one of these men take this work in his hand, I wonder that he does not put it to his nose, like a monkey, or ask me if it is something good to eat.

∾

And those men who are inventors and interpreters between Nature and Man, as compared with boasters and declaimers of the works of others, must be regarded and not otherwise esteemed than as the object in front of a mirror, when compared with its

image seen in the mirror. For the first is something in itself, and the other nothingness – folks little indebted to Nature, since it is only by chance that they wear the human form and without it I might class them with the herds of beasts.

2

On painting in general

✤

The sorest misfortune is when your views are in advance of your work.

☙

The first thing in painting is that the objects it represents should appear in relief, and that the grounds surrounding them at different distances shall appear within the vertical plane of the foreground of the picture by means of the 3 branches of Perspective, which are: the diminution in the distinctness of the forms of the objects; the diminution in their magnitude; and the diminution in their colour. And of these 3 classes of Perspective the first results from (the structure of) the eye, while the other two are caused by the atmosphere which intervenes between the eye and the objects seen by it. The second essential in painting is appropriate action

and a due variety in the figures, so that the men may not all look like brothers, &c.

∾

The painter who draws merely by practice and by eye, without any reason, is like a mirror which copies everything placed in front of it without being conscious of their existence.

∾

Painting is concerned with all the 10 attributes of sight, which are: Darkness, Light, Solidity and Colour, Form and Position, Distance and Propinquity, Motion and Rest. This little work of mine will be a tissue [of the studies] of these attributes, reminding the painter of the rules and methods by which he should use his art to imitate all the works of Nature which adorn the world.

∾

If the eye is required to look at an object placed too near to it, it cannot judge of it well – as happens to a man who tries to see the tip of his nose. Hence, as a general rule, Nature teaches us that an object can never be seen perfectly unless the space between

it and the eye is equal, at least, to the length of the face.

∾

Objects seen by one and the same eye appear sometimes large, and sometimes small.

∾

Experiment [showing] the dilatation and contraction of the pupil, from the motion of the sun and other luminaries. In proportion as the sky is darker the stars appear of larger size, and if you were to light up the medium these stars would look smaller; and this difference arises solely from the pupil which dilates and contracts with the amount of light in the medium which is interposed between the eye and

the luminous body. Let the experiment be made, by placing a candle above your head at the same time that you look at a star; then gradually lower the candle till it is on a level with the ray that comes from the star to the eye, and then you will see the star diminish so much that you will almost lose sight of it.

3

The perspective of disappearance

✥

When I was once in a place on the sea, at an equal distance from the shore and the mountains, the distance from the shore looked much greater than that from the mountains.

∼

The eye cannot take in a luminous angle which is too close to it.

∼

Of several bodies, all equally large and equally distant, that which is most brightly illuminated will appear to the eye nearest and largest.

4

On the theory of colours

✥

An object represented in white and black will display stronger relief than in any other way; hence I would remind you O Painter! to dress your figures in the lightest colours you can, since, if you put them in dark colours, they will be in too slight relief and inconspicuous from a distance. And the reason is that the shadows of all objects are dark. And if you make a dress dark there is little variety in the lights and shadows, while in light colours there are many grades.

∾

The colours of the rainbow are not produced by the sun, for they occur in many ways without the sunshine; as may be seen by holding a glass of water up to the eye; when, in the glass – where there are those minute bubbles always seen in coarse glass

43

– each bubble, even though the sun does not fall on it, will produce on one side all the colours of the rainbow; as you may see by placing the glass between the day light and your eye in such a way as that it is close to the eye, while on one side the glass admits the [diffused] light of the atmosphere, and on the other side the shadow of the wall on one side of the window; either left or right, it matters not which. Then, by turning the glass round you will see these colours all round the bubbles in the glass &c. And the rest shall be said in its place.

❧

In the experiment just described, the eye would seem to have some share in the colours of the rainbow, since these bubbles in the glass do not display the colours except through the medium of the eye. But, if you place the glass full of water

on the window sill, in such a position as that the outer side is exposed to the sun's rays, you will see the same colours produced in the spot of light thrown through the glass and upon the floor, in a dark place, below the window; and as the eye is not here concerned in it, we may evidently, and with certainty pronounce that the eye has no share in producing them.

5

Aerial perspective

✣

There is another kind of perspective which I call
Aerial Perspective, because by the atmosphere we
are able to distinguish the variations in distance of
different buildings, which appear placed on a single
line; as, for instance, when we see several buildings
beyond a wall, all of which, as they appear above
the top of the wall, look of the same size, while
you wish to represent them in a picture as more
remote one than another and to give the effect of a
somewhat dense atmosphere. You know that in an
atmosphere of equal density the remotest objects

seen through it, as mountains, in consequence of the great quantity of atmosphere between your eye and them – appear blue and almost of the same hue as the atmosphere itself when the sun is in the East. Hence you must make the nearest building above the wall of its real colour, but the more distant ones make less defined and bluer. Those you wish should look farthest away you must make proportionately bluer; thus, if one is to be five times as distant, make it five times bluer. And by this rule the buildings which above a [given] line appear of the same size, will plainly be distinguished as to which are the more remote and which larger than the others.

6

On the proportions and movements of the human figure

✤

Every man, at three years old, is half the full height he will grow to at last.

～,

The foot is as much longer than the hand as the thickness of the arm at the wrist where it is thinnest seen facing.

Again, you will find that the foot is as much longer than the hand as the space between the inner

angle of the little toe to the last projection of the big toe, if you measure along the length of the foot.

The palm of the hand without the fingers goes twice into the length of the foot without the toes.

If you hold your hand with the fingers straight out and close together you will find it to be of the same width as the widest part of the foot, that is where it is joined onto the toes.

And if you measure from the prominence of the inner ankle to the end of the great toe you will find this measure to be as long as the whole hand.

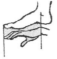

From the top angle of the foot to the insertion of the toes is equal to the hand from wrist joint to the tip of the thumb.

The smallest width of the hand is equal to the smallest width of the foot between its joint into the leg and the insertion of the toes.

The width of the heel at the lower part is equal to that of the arm where it joins the hand; and also to the leg where it is thinnest when viewed in front.

The length of the longest toe, from its first division from the great toe to its tip is the fourth of

the foot from the centre of the ankle bone to the tip, and it is equal to the width of the mouth. The distance between the mouth and the chin is equal to that of the knuckles and of the three middle fingers and to the length of their first joints if the hand is spread, and equal to the distance from the joint of the thumb to the outset of the nails, that is the fourth part of the hand and of the face.

The space between the extreme poles inside and outside the foot called the ankle or ankle bone *a b* is equal to the space between the mouth and the inner corner of the eye.

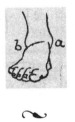

The foot, from where it is attached to the leg, to the tip of the great toe is as long as the space between the upper part of the chin and the roots of the hair *a b*; and equal to five sixths of the face.

The length of the foot from the end of the toes to the heel goes twice into that from the heel to the knee, that is where the leg bone [fibula] joins the thigh bone [femur].

In kneeling down a man will lose the fourth part of his height.

When a man kneels down with his hands folded on his breast the navel will mark half his height and likewise the points of the elbows.

Half the height of a man who sits – that is from the seat to the top of the head – will be where the

arms fold below the breast, and below the shoulders. The seated portion – that is from the seat to the top of the head – will be more than half the man's [whole height] by the length of the scrotum.

A man when he lies down is reduced to one ninth of his height.

The hand from the longest finger to the wrist joint goes 4 times from the tip of the longest finger to the shoulder joint.

There is a great difference in the length between the joints in men and boys for, in man, from the top of the shoulder [by the neck] to the elbow, and from the elbow to the tip of the thumb and from one shoulder to the other, is in each instance two heads, while in a boy it is but one because Nature constructs in us the mass which is the home of the

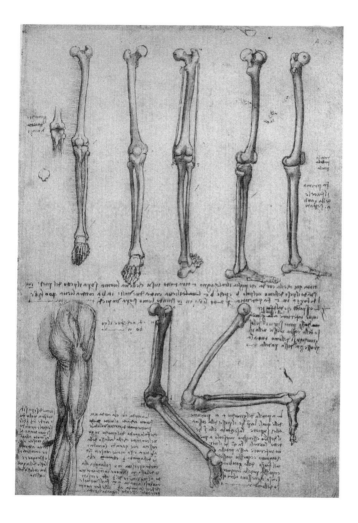

intellect, before forming that which contains the vital elements.

∾

Which are the muscles which subdivide in old age or in youth, when becoming lean? Which are the parts of the limbs of the human frame where no amount of fat makes the flesh thicker, nor any degree of leanness ever diminishes it?

The thing sought for in this question will be found in all the external joints of the bones, as the shoulder, elbow, wrists, finger-joints, hips, knees, ankle-bone and toes and the like; all of which shall be told in its place. The greatest thickness acquired by any limb is at the part of the muscles which is farthest from its attachments.

Flesh never increases on those portions of the limb where the bones are near to the surface.

∾

A sitting man cannot raise himself if that part of his body which is front of his axis [centre of gravity] does not weigh more than that which is behind that axis [or centre] without using his arms.

∾

In going up stairs, if you place your hands on your knees all the labour taken by the arms is removed from the sinews at the back of the knees.

∿

How a man proceeds to raise himself to his feet, when he is sitting on level ground.

7

Moral precepts for the student of painting

✤

Many are they who have a taste and love for drawing, but no talent; and this will be discernible in boys who are not diligent and never finish their drawings with shading.

(～

The youth should first learn perspective, then the proportions of objects. Then he may copy from some good master, to accustom himself to fine forms. Then from nature, to confirm by practice the rules he has learnt. Then see for a time the works of various masters. Then get the habit of putting his art into practice and work.

～

It is indispensable to a Painter who would be thoroughly familiar with the limbs in all the positions

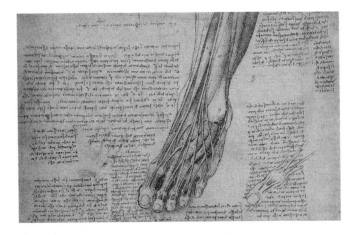

and actions of which they are capable, in the nude,
to know the anatomy of the sinews, bones, muscles
and tendons so that, in their various movements and
exertions, he may know which nerve or muscle is
the cause of each movement and show those only
as prominent and thickened, and not the others
all over [the limb], as many do who, to seem great
draughtsmen, draw their nude figures looking like
wood, devoid of grace; so that you would think you
were looking at a sack of walnuts rather than the
human form, or a bundle of radishes rather than the
muscles of figures.

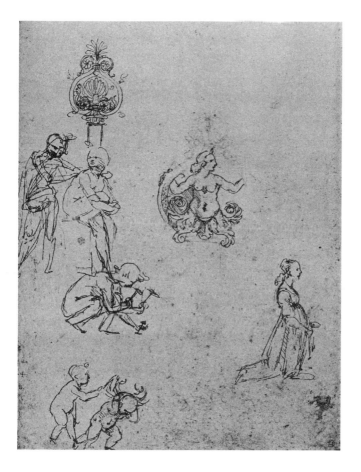

The painter who is familiar with the nature of the sinews, muscles, and tendons, will know very well, in giving movement to a limb, how many and which sinews cause it; and which muscle, by swelling, causes the contraction of that sinew; and which sinews, expanded into the thinnest cartilage, surround and support the said muscle. Thus he will variously and constantly demonstrate the different muscles by means of the various attitudes of his figures, and will not do, as many who, in a variety of movements, still display the very same things [modelling] in the arms, back, breast and legs. And these things are not to be regarded as minor faults.

∾

I say that first you ought to learn the limbs and their mechanism, and having this knowledge, their actions should come next, according to the circum-stances in which they occur in man. And thirdly to compose subjects, the studies for which should be taken from natural actions and made from time to time, as circumstances allow; and pay attention to them in the streets and *piazze* and fields, and note them down with a brief indication of the forms; thus for a head make an 'o', and for an arm a straight or a bent line, and the same for the legs and the

body, and when you return home work out these notes in a complete form. The Adversary says that to acquire practice and do a great deal of work it is better that the first period of study should be employed in drawing various compositions done on paper or on walls by diverse masters, and that in this way practice is rapidly gained, and good methods; to which I reply that the method will be good, if it is based on works of good composition and by skilled masters. But since such masters are so rare that there are but few of them to be found, it is a surer way to go to natural objects, than to those which are imitated from nature with great deterioration, and

so form bad methods; for he who can go to the fountain does not go to the water-jar.

We know for certain that sight is one of the most rapid actions we can perform. In an instant we see an infinite number of forms, still we only take in thoroughly one object at a time. Supposing that you, Reader, were to glance rapidly at the whole of this written page, you would instantly perceive that it was covered with various letters; but you could not, in the time, recognise what the letters were, nor what they were meant to tell. Hence you would need to see them word by word, line by line to be able to understand the letters. Again, if you wish to go to the top of a building you must go up step by step; otherwise it will be impossible that you should reach the top. Thus I say to you, whom nature prompts to pursue this art, if you wish to have a sound knowledge of the forms of objects begin with the details of them, and do not go on to the second step till you have the first well fixed in memory and in practice. And if you do otherwise you will throw away your time, or certainly greatly prolong your studies. And remember to acquire diligence rather than rapidity.

∽

A painter needs such mathematics as belong to painting. And the absence of all companions who are alienated from his studies; his brain must be easily impressed by the variety of objects, which successively come before him, and also free from other cares. And if, when considering and defining one subject, a second subject intervenes – as happens when an object occupies the mind – then he must decide which of these cases is the more difficult to work out, and follow that up until it becomes quite clear, and then work out the explanation of the other. And above all he must keep his mind as clear as the surface of a mirror, which assumes colours as various as those of the different objects. And his companions should be like him as to their studies, and if such cannot be found he should keep his speculations to himself alone, so that at least he will find no more useful company than his own.

∽

To the end that well-being of the body may not injure that of the mind, the painter or draughtsman must remain solitary, and particularly when intent on those studies and reflections which will constantly rise up before his eye, giving materials to

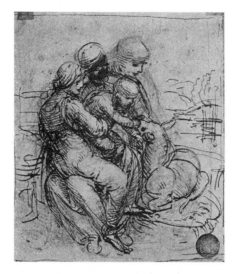

be well stored in the memory. While you are alone you are entirely your own master and if you have one companion you are but half your own, and the less so in proportion to the indiscretion of his behaviour. And if you have many companions you will fall deeper into the same trouble. If you should say: 'I will go my own way and withdraw apart, the better to study the forms of natural objects,' I tell you, you will not be able to help often listening to their chatter. And so, since one cannot serve two masters, you will badly fill the part of a companion, and carry out your studies of art even worse. And

if you say: 'I will withdraw so far that their words cannot reach me and they cannot disturb me,' I can tell you that you will be thought mad. But, you see, you will at any rate be alone. And if you must have companionship find it in your studio. This may assist you to have the advantages which arise from various speculations. All other company may be highly mischievous.

∾

I say and insist that drawing in company is much better than alone, for many reasons. The first is that you would be ashamed to be seen behindhand among the students, and such shame will lead you to careful study. Secondly, a wholesome emulation will stimulate you to be among those who are more praised than yourself, and this praise of others will spur you on. Another is that you can learn from the drawings of others who do better than yourself; and if you are better than they, you can profit by your contempt for their defects, while the praise of others will incite you to farther merits.

∾

He is a poor disciple who does not excel his master.

∾

Nor is the painter praiseworthy who does but one thing well, as the nude figure, heads, draperies, animals, landscapes or other such details, irrespective of other work; for there can be no mind so inept, that after devoting itself to one single thing and doing it constantly, it should fail to do it well.

∾

Now there is a certain race of painters who, having studied but little, must need take as their standard of beauty mere gold and azure, and these, with supreme conceit, declare that they will not give good work for miserable payment, and that they could do as well as any other if they were well paid. But, ye foolish folks! Cannot such artists keep some good work, and then say: this is a costly work and this more moderate and this is average work and show that they can work at all prices?

∾

Nature has beneficently provided that throughout the world you may find something to imitate.

∾

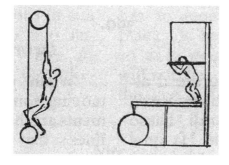

The mind of the painter must resemble a mirror, which always takes the colour of the object it reflects and is completely occupied by the images of as many objects as are in front of it. Therefore you must know, O Painter! that you cannot be a good one if you are not the universal master of representing by your art every kind of form produced by nature. And this you will not know how to do if you do not see them, and retain them in your mind. Hence as you go through the fields, turn your attention to various objects, and, in turn look now at this thing and now at that, collecting a store of diverse facts selected and chosen from those of less value. But do not do like some painters who, when they are wearied with exercising their fancy dismiss their work from their thoughts and take exercise in walking for relaxation, but still keep fatigue in

their mind which, though they see various objects around them, do not apprehend them; but, even when they meet friends or relations and are saluted by them, although they see and hear them, take no more cognisance of them than if they had met so much empty air.

∾

When, O Draughtsmen, you desire to find relaxation in games you should always practise such things as may be of use in your profession, by giving your eye good practice in judging accurately of the breadth and length of objects. Thus, to accustom your mind to such things, let one of you draw a straight line at random on a wall, and each of you, taking a blade of grass or of straw in his hand, try to cut it to the length that the line drawn appears to him to be, standing at a distance of 10 braccia; then each one may go up to the line to measure the length he has judged it to be. And he who has come nearest with his measure to the length of the pattern is the best man, and the winner, and shall receive the prize you have settled beforehand. Again you should take foreshortened measures: that is take a spear, or any other cane or reed, and fix on a point at a certain distance; and let each one estimate how many times

he judges that its length will go into that distance. Again, who will draw best a line one braccio long, which shall be tested by a thread. And such games give occasion to good practice for the eye, which is of the first importance in painting.

∼

I cannot forbear to mention among these precepts a new device for study which, although it may seem but trivial and almost ludicrous, is nevertheless extremely useful in arousing the mind to various inventions. And this is, when you look at a wall spotted with stains, or with a mixture of stones, if you have to devise some scene, you may discover a resemblance to various landscapes, beautified with mountains, rivers, rocks, trees, plains, wide valleys and hills in varied arrangement; or again you may see battles and figures in action; or strange faces and costumes, and an endless variety of objects, which you could reduce to complete and well-drawn forms. And these appear on such walls confusedly, like the sound of bells in whose jangle you may find any name or word you choose to imagine.

8

Judging a picture

❖

We know very well that errors are better recognised in the works of others than in our own; and that often, while reproving little faults in others, you may ignore great ones in yourself. To avoid such ignorance, in the first place make yourself a master

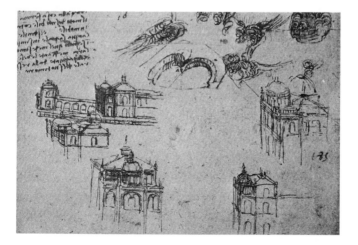

of perspective, then acquire perfect knowledge of the proportions of men and other animals, and also, study good architecture, that is so far as concerns the forms of buildings and other objects which are on the face of the earth; these forms are infinite, and the better you know them the more admirable will your work be. And in cases where you lack experience do not shrink from drawing them from nature. But, to carry out my promise above [in the title] – I say that when you paint you should have a flat mirror and often look at your work as reflected in it, when you will see it reversed, and it will appear to you like some other painter's work, so you will be better able to judge of its faults than in any other way. Again, it is well that you should often leave off work and take a little relaxation, because, when you come back to it you are a better judge; for sitting too close at work may greatly deceive you. Again, it is good to retire to a distance because the work looks smaller and your eye takes in more of it at a glance and sees more easily the discords or disproportion in the limbs and colours of the objects.

Certainly while a man is painting he ought not to shrink from hearing every opinion. For we know

very well that a man, though he may not be a painter, is familiar with the forms of other men and very capable of judging whether they are humpbacked, or have one shoulder higher or lower than the other, or too big a mouth or nose, and other defects; and, as we know that men are competent to judge of the works of nature, how much more ought we to admit that they can judge of our errors; since you know how much a man may be deceived in his own work. And if you are not conscious of this in yourself study it in others and profit by their faults. Therefore be curious to hear with patience the opinions of others, consider and weigh well whether those who find fault have ground or not for blame, and, if so amend; but, if not make as though you had not heard, or if he should be a man you esteem show him by argument the cause of his mistake.

∽

The point of sight must be at the level of the eye of an ordinary man, and the farthest limit of the plain where it touches the sky must be placed at the level of that line where the earth and sky meet; excepting mountains, which are independent of it.

☙

When you draw from nature stand at a distance of 3 times the height of the object you wish to draw.

☙

The universal practice which painters adopt on the walls of chapels is greatly and reasonably to be condemned. Inasmuch as they represent one historical subject on one level with a landscape and buildings, and then go up a step and paint another, varying the point [of sight], and then a third and a fourth, in such a way as that on one wall there are four points of sight, which is supreme folly in such painters. We know that the point of sight is opposite the eye of the spectator of the scene; and if you would [have me] tell you how to represent the life of a saint divided into several pictures on one and the same wall, I answer that you must set out the foreground with its point of sight on a level with the eye of the spectator of the scene, and upon this plane represent the more important part of the story large, and then, diminishing by degrees the figures, and the buildings on various hills and open spaces, you can represent all the events of the history. And on the remainder of the wall up to the top put trees, large as compared with the figures, or angels if they

are appropriate to the story, or birds or clouds or
similar objects; otherwise do not trouble yourself
with it for your whole work will be wrong.

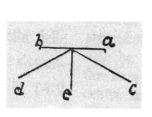

Supposing *a b* to be the picture and *d* to be the light,
I say that if you place yourself between *c* and *e* you
will not understand the picture well and particularly
if it is done in oils, or still more if it is varnished,
because it will be lustrous and somewhat of the
nature of a mirror. And for this reason the nearer
you go towards the point *c*, the less you will see,
because the rays of light falling from the window
on the picture are reflected to that point. But if you
place yourself between *e* and *d* you will get a good
view of it, and the more so as you approach the
point *d*, because that spot is least exposed to these
reflected rays of light.

9

On light and shade

✣

Where the shadow should be on the face.

∾

First you must consider whether the figures have the relief required by their situation and the light which illuminates them; for the shadows should not be the same at the extreme ends of the composition as in the middle, because it is one thing when figures are surrounded by shadows and another when they have shadows only on one side. Those which are in the middle of the picture are surrounded by shadows, because they are shaded by the figures which stand between them and the light. And those

are lighted on one side only which stand between the principal group and the light, because where they do not look towards the light they face the group and the darkness of the group is thrown on them: and where they do not face the group they face the brilliant light and it is their own darkness shadowing them, which appears there.

10

Observing

✦

When you have well learnt perspective and have by heart the parts and forms of objects, you must go about, and constantly, as you go, observe, note and consider the circumstances and behaviour of men in talking, quarrelling or laughing or fighting together – the action of the men themselves and the actions of the bystanders, who separate them or who look on. And take a note of them with slight strokes, in a little book which you should always carry with you. And it should be of tinted paper, that it may not be rubbed out, but change the old when full for a new one; since these things should not be rubbed out but preserved with great care; for the forms, and positions of objects are so infinite that the memory is incapable of retaining them, wherefore keep these sketches as your guides and masters. .

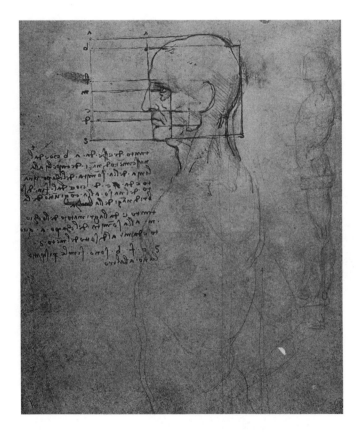

If you want to acquire facility for bearing in mind
the expression of a face, first make yourself familiar
with a variety of [forms of] several heads, eyes,

noses, mouths, chins and cheeks and necks and
shoulders. And to put a case: noses are of 10 types:
straight, bulbous, hollow, prominent above or below
the middle, aquiline, regular, flat, round or pointed.
These hold good as to profile. In full face they are
of 11 types: these are equal thick in the middle,
thin in the middle, with the tip thick and the root
narrow, or narrow at the tip and wide at the root;
with the nostrils wide or narrow, high or low, and
the openings wide or hidden by the point; and you
will find an equal variety in the other details, which
things you must draw from nature and fix them in
your mind. Or else, when you have to draw a face
by heart, carry with you a little book in which you
have noted such features; and when you have cast a
glance at the face of the person you wish to draw,
you can look, in private, which nose or mouth is
most like, or there make a little mark to recognise it
again at home. Of grotesque faces I need say nothing,
because they are kept in mind without difficulty.

II

Gestures and character

✜

Old men ought to be represented with slow and heavy movements, their legs bent at the knees, when they stand still, and their feet placed parallel and apart; bending low with the head leaning forward, and their arms but little extended.

Women must be represented in modest attitudes, their legs close together, their arms closely folded, their heads inclined and somewhat on one side.

Old women should be represented with eager, swift and furious gestures, like infernal furies; but the action should be more violent in their arms and head than in their legs.

Little children should be represented with lively and contorted movement when sitting, and, when standing still, in shy and timid attitudes.

∽

You must make an angry person holding someone by the hair, wrenching his head against the ground, and with one knee on his ribs; his right arm and fist raised on high. His hair must be thrown up, his brow downcast and knit, his teeth clenched and the two corners of his mouth grimly set; his neck swelled and bent forward as he leans over his foe, and full of furrows.

∾

You must show a man in despair with a knife, having already torn open his garments, and with one hand tearing open the wound. And make him standing on his feet and his legs somewhat bent and his whole person leaning towards the earth; his hair flying in disorder.

∾

You know that you cannot invent animals without limbs, each of which, in itself, must resemble those of some other animal. Hence if you wish to make an animal, imagined by you, appear natural – let us say a Dragon – take for its head that of a mastiff or hound, with the eyes of a cat, the ears of a porcupine, the nose of a greyhound, the brow of a lion, the temples of an old cock, the neck of a water tortoise.

It seems to me to be no small charm in a painter when he gives his figures a pleasing air, and this grace, if he have it not by nature, he may acquire by incidental study in this way: look about you and take the best parts of many beautiful faces, of which the beauty is confirmed rather by public fame than by your own judgement; for you might be mistaken and choose faces which have some resemblance to your own. For it would seem that such resemblances often please us; and if you should be ugly, you would select faces that were not beautiful and you would then make ugly faces, as many painters do. For often

a master's work resembles himself. So select beauties as I tell you, and fix them in your mind.

A picture or representation of human figures ought to be done in such a way as that the spectator may easily recognise, by means of their attitudes, the purpose in their minds. Thus, if you have to represent a man of noble character in the act of speaking, let his gestures be such as naturally accompany good words; and, in the same way, if you wish to depict a man of a brutal nature, give him fierce movements; as with his arms flung out towards the listener, and his head and breast thrust forward beyond his feet, as if following the speaker's hands. Thus it is with a deaf and dumb person who, when he sees two men in conversation – although he is deprived of hearing – can nevertheless understand, from the attitudes and gestures of the speakers, the nature of their discussion. I once saw in Florence a man who had become deaf who, when you spoke very loud did not understand you, but if you spoke gently and without making any sound, understood merely from the movement of the lips. Now perhaps you will say that the lips of a man who speaks loudly do not move like those of one speaking softly, and that

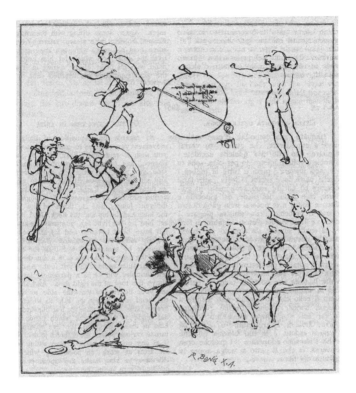

if they were to move them alike they would be alike understood. As to this argument, I leave the decision to experiment; make a man speak to you gently and note [the motion of] his lips.

When you wish to represent a man speaking to a number of people, consider the matter of which he has to treat and adapt his action to the subject. Thus, if he speaks persuasively, let his action be appropriate to it. If the matter in hand be to set forth an argument, let the speaker, with the fingers of the right hand hold one finger of the left hand, having the two smaller ones closed, and his face alert, and turned towards the people with mouth a little open, to look as though he spoke; and if he is sitting let him appear as though about to rise, with his head forward. If you represent him standing make him lean slightly forward with body and head towards the people. These you must represent as silent and attentive, all looking at the orator's face with gestures of admiration; and make some old men in astonishment at the things they hear, with the corners of their mouths pulled down and drawn in, their cheeks full of furrows, and their eyebrows raised, and wrinkling the forehead where they meet. Again, some sitting with their fingers clasped holding their weary knees. Again, some bent old man, with one knee crossed over the other, on which let him hold his hand with his other elbow resting in it and the hand supporting his bearded chin.

12

The artist's materials

❖

Very excellent will be a stiff white paper, made of
the usual mixture and filtered milk of an herb called
calves foot; and when this paper is prepared and
dampened and folded and wrapped up it may be
mixed with the mixture and thus left to dry; but
if you break it before it is moistened it becomes
somewhat like the thin paste called *lasagne* and you
may then dampen it and wrap it up and put it in the
mixture and leave it to dry.

෴

If you want to restore oil colours that have become
dry keep them soaking in soft soap for a night and,
with your finger, mix them up with the soft soap;
then pour them into a cup and wash them with
water, and in this way you can restore colours that
have got dry. But take care that each colour has its

own vessel to itself, adding the colour by degrees as you restore it and mind that they are thoroughly softened, and when you wish to use them for *tempera* wash them five and six times with spring water, and leave them to settle; if the soft soap should be thick with any of the colours pass it through a filter.

13

Philosophy of the art of painting

✤

What is fair in men passes away, but not so in art.

◦◦◦

If you condemn painting, which is the only imitator
of all visible works of nature, you will certainly
despise a subtle invention which brings philosophy
and subtle speculation to the consideration of the
nature of all forms – seas and plains, trees, animals,
plants and flowers – produced by nature, and these
her children have given birth to painting. Hence
we may justly call it the grandchild of nature and
related to God.

◦◦◦

The eye, which is called the window of the soul,
is the principal means by which the central sense
can most completely and abundantly appreciate the
infinite works of nature; and the ear is the second,

which acquires dignity by hearing of the things the eye has seen. If you, historians, or poets, or mathematicians, had not seen things with your eyes you could not report of them in writing. And if you, O poet, tell a story with your pen, the painter with his brush can tell it more easily, with simpler completeness and less tedious to be understood. And if you call painting dumb poetry, the painter may call poetry blind painting. Now which is the worse defect? To be blind or dumb? Though the poet is as free as the painter in the invention of his fictions they are not so satisfactory to men as paintings; for, though poetry is able to describe forms, actions and places in words, the painter deals with the actual similitude of the forms, in order to represent them. Now tell me which is the nearer to the actual man: the name of man or the image of the man. The name of man differs in different countries, but his form is never changed but by death.

As soon as the poet ceases to represent in words what exists in nature, he in fact ceases to resemble the painter; for if the poet, leaving such representation, proceeds to describe the flowery and flattering speech of the figure, which he wishes to make

the speaker, he then is an orator and no longer a poet nor a painter. And if he speaks of the heavens he becomes an astrologer, and philosopher; and a theologian, if he discourses of nature or God. But, if he restricts himself to the description of objects, he would enter the lists against the painter, if with words he could satisfy the eye as the painter does.

❧

Though you may be able to tell or write the exact description of forms, the painter can so depict them that they will appear alive, with the shadow and light which show the expression of a face; which you cannot accomplish with the pen though it can be achieved by the brush.

❧

The first drawing was a simple line drawn round the shadow of a man cast by the sun on a wall.

❧

The painter strives and competes with nature.

14

Allegorical representations

✛

Il Moro as representing Good Fortune, with hair, and robes, and his hands in front, and Messer Gualtieri taking him by the robes with a respectful air from below, having come in from the front.

Again, Poverty in a hideous form running behind a youth. Il Moro covers him with the skirt of his robe, and with his gilt sceptre he threatens the monster.

A plant with its roots in the air to represent one who is at his last; – a robe and Favour.

Those who trust themselves to live near him, and who will be a large crowd, these shall all die cruel deaths; and fathers and mothers together with their families will be devoured and killed by cruel creatures.

∾

Above the helmet place a half globe, which is to signify our hemisphere, in the form of a world; on which let there be a peacock, richly decorated, and with his tail spread over the group; and every ornament belonging to the horse should be of peacock's feathers on a gold ground, to signify the beauty which comes of the grace bestowed on him who is a good servant.

On the shield a large mirror to signify that he who truly desires favour must be mirrored in his virtues.

On the opposite side will be represented fortitude, in like manner in her place with her pillar in her hand, robed in white. And all crowned; and Prudence with three eyes. The housing of the horse should be of plain cloth of gold closely sprinkled with peacock's eyes, and this holds good for all the

housings of the horse, and the man's dress. And the man's crest and his neck-chain are of peacock's feathers on golden ground.

On the left side will be a wheel, the centre of which should be attached to the centre of the horse's hinder thigh piece, and in the centre Prudence is seen robed in red, Charity sitting in a fiery chariot and with a branch of laurel in her hand, to signify the hope which comes of good service.

∽

Pleasure and Pain represent as twins, since there never is one without the other; and as if they were united back to back, since they are contrary to each other.

Clay, gold.

If you take Pleasure know that he has behind him one who will deal you Tribulation and Repentance.

∽

Envy must be represented with a contemptuous motion of the hand towards heaven, because if she could she would use her strength against God; make her with her face covered by a mask of fair seeming; show her as wounded in the eye by a palm branch

and by an olive-branch, and wounded in the ear by laurel and myrtle, to signify that victory and truth are odious to her. Many thunderbolts should proceed from her to signify her evil speaking. Let her be lean and haggard because she is in perpetual torment. Make her heart gnawed by a swelling serpent, and make her with a quiver with tongues serving as arrows, because she often offends with it. Give her a leopard's skin, because this creature kills the lion out of envy and by deceit. Give her too a vase in her hand full of flowers and scorpions and toads and other venomous creatures; make her ride upon death, because Envy, never dying, never tires of ruling. Make her bridle, and load her with diverse kinds of arms because all her weapons are deadly.

Toleration.

Intolerable.

No sooner is Virtue born than Envy comes into the world to attack it; and sooner will there be a body without a shadow than Virtue without Envy.

15

Mottoes and emblems

✠

Stubborn rigour.
 Doomed rigour.

∾

Ivy is a type of longevity.

∾

Movement will cease before we are weary of being useful.

 Movement will fail sooner than usefulness.

 Death sooner than weariness. I am never weary of being useful, is a motto for carnival.

 In serving others I cannot do enough. Without fatigue.

 No labour is sufficient to tire me.

 Hands into which ducats and precious stones fall like snow; they never become tired by serving, but

this service is only for its utility and not for our own benefit. I am never weary of being useful.

Naturally nature has so disposed me.

∾

Fame alone raises herself to Heaven, because virtuous things are in favour with God.

Disgrace should be represented upside down, because all her deeds are contrary to God and tend to hell.

∾

Nothing is so much to be feared as Evil Report.

This Evil Report is born of life.

A felled tree which is shooting again.
 I am still hopeful.
 A falcon,
 Time.

Short liberty.

16

Notes on sculpture

✣

If you wish to make a figure in marble, first make one of clay, and when you have finished it, let it dry and place it in a case which should be large enough,

after the figure is taken out of it, to receive also the marble, from which you intend to reveal the figure in imitation of the one in clay. After you have put the clay figure into this said case, have little rods which will exactly slip into the holes in it, and thrust them so far in at each hole that each white rod may touch the figure in different parts of it. And colour the portion of the rod that remains outside black, and mark each rod and each hole with a counter-sign so that each may fit into its place. Then take the clay figure out of this case and put in your piece of marble, taking off so much of the marble that all your rods may be hidden in the holes as far as their marks; and to be the better able to do this, make the case so that it can be lifted up; but the bottom of it will always remain under the marble and in this way it can be lifted with tools with great ease.

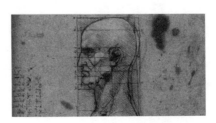

Divide the head into 12 degrees, and each degree divide into 12 points, and each point into 12 minutes, and the minutes into minims and the minims into semi minims.

Degree – point – minute – minim.

༄

Sculptured figures which appear in motion, will, in their standing position, actually look as if they are falling forward.

༄

Salt may be made from human excrements, burnt and calcined, made into lees and dried slowly at a fire, and all the excrements produce salt in a similar way and these salts, when distilled, are very strong.

༄

There is to be seen, in the mountains of Parma and Piacenza, a multitude of shells and corals full of holes, still sticking to the rocks, and when I was at work on the great horse for Milan, a large sackful of them, which were found thereabout, was brought to me into my workshop, by certain peasants.

༄

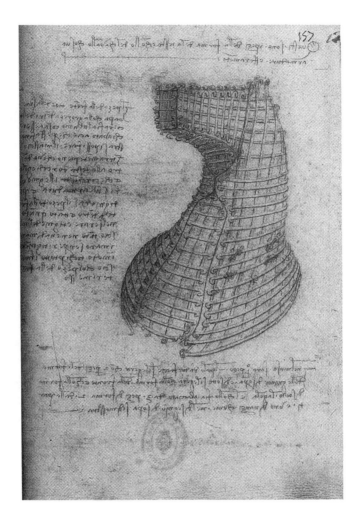

Believe me, Leonardo the Florentine, who has to do the equestrian bronze statue of the Duke Francesco that he does not need to care about it, because he has work for all his lifetime, and, being so great a work, I doubt whether he can ever finish it.

∼

If you want a fine blue colour dissolve the smalt made with tartar, and then remove the salt.

Vitrified brass makes a fine red.

∼

Such as the mould is, so will the cast be.

17

Observations on architecture

✣

Let the width of the streets be equal to the average height of the houses.

∽

The Palace of the prince must have a piazza in front of it.

Houses intended for dancing or any kind of jumping or any other movements with a multitude of people must be on the ground-floor; for I have already witnessed the destruction of some, causing death to many persons, and above all let every wall, be it ever so thin, rest on the ground or on arches with a good foundation.

Let the mezzanines of the dwellings be divided by walls made of very thin bricks, and without wood on account of fire.

Let all the privies have ventilation [by shafts] in the thickness of the walls, so as to exhale by the roofs.

The mezzanines should be vaulted, and the vaults will be stronger in proportion as they are of small size.

The ties of oak must be enclosed in the walls in order to be protected from fire.

A building should always be detached on all sides so that its form may be seen.

It never looks well to see the roofs of a church; they should rather be flat and the water should run off by gutters made in the frieze.

∽

The water should be allowed to fall from the whole circle *a b*.

∽

The arch is nothing else than a force originated by two weaknesses, for the arch in buildings is composed of two segments of a circle, each of which being very weak in itself tends to fall; but as each opposes this tendency in the other, the two weaknesses combine to form one strength.

As the arch is a composite force it remains in equi-
librium because the thrust is equal from both sides;
and if one of the segments weighs more than the
other the stability is lost, because the greater pressure
will outweigh the lesser.

Next to giving the segments of the circle equal
weight it is necessary to load them equally, or you
will fall into the same defect as before.

The way to give stability to the arch is to fill the
spandrels with good masonry up to the level of its
summit.

The first and most important thing is stability.

As to the foundations of the component parts of
temples and other public buildings, the depths of

the foundations must bear the same proportions to each other as the weight of material which is to be placed upon them.

Every part of the depth of earth in a given space is composed of layers, and each layer is composed of heavier or lighter materials, the lowest being the heaviest. And this can be proved, because these layers have been formed by the sediment from water carried down to the sea, by the current of rivers which flow into it. The heaviest part of this sediment was that which was first thrown down, and so on by degrees; and this is the action of water when it becomes stagnant, having first brought down the mud whence it first flowed. And such layers of soil are seen in the banks of rivers, where their constant flow has cut through them and divided one slope from the other to a great depth; where in gravelly strata the waters have run off, the materials have, in consequence, dried and been converted into hard stone, and this happened most in what was the finest mud; whence we conclude that every portion of the surface of the earth was once at the centre of the earth, and *vice versa* &c.

❧

The window *a* is well placed under the window *c*, and the window *b* is badly placed under the pier *d*, because this latter is without support and foundation; mind therefore never to make a break under the piers between the windows.

❧

The angle will offer the greatest resistance which is most acute, and the most obtuse will be the weakest.

❧

The beam which is more than 20 times as long as its greatest thickness will be of brief duration and will break in half; and remember, that the part built into the wall should be steeped in hot pitch and filleted with oak boards likewise so steeped. Each beam must pass through its walls and be secured beyond the walls with sufficient chaining, because in consequence of earthquakes the beams are often seen

to come out of the walls and bring down the walls and floors; whilst if they are chained they will hold the walls strongly together and the walls will hold the floors. Again I remind you never to put plaster over timber. Since by expansion and shrinking of the timber produced by damp and dryness such floors often crack, and once cracked their divisions gradually produce dust and an ugly effect. Again remember not to lay a floor on beams supported on arches; for, in time the floor which is made on beams settles somewhat in the middle while that part of the floor which rests on the arches remains in its place; hence, floors laid over two kinds of supports look, in time, as if they were made in hills.

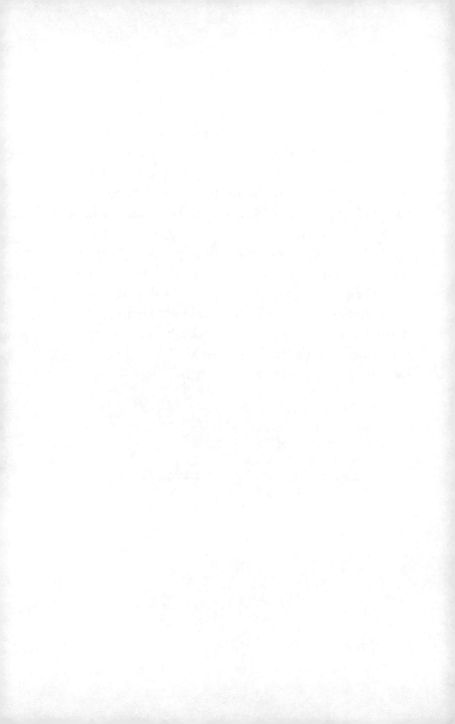

18

Anatomy

✣

I wish to work miracles; – it may be that I shall possess less than other men of more peaceful lives, or than those who want to grow rich in a day. I may live for a long time in great poverty, as always happens, and to all eternity will happen, to alchemists, the would-be creators of gold and silver, and to engineers who would have dead water stir itself into life and perpetual motion, and to those supreme fools, the necromancer and the enchanter.

And you, who say that it would be better to watch an anatomist at work than to see these drawings, you would be right, if it were possible to observe all the things which are demonstrated in such drawings in a single figure, in which you, with all your cleverness, will not see nor obtain knowledge of more than some few veins, to obtain a true and perfect knowledge of which I have dissected more than ten human bodies, destroying all the other members, and

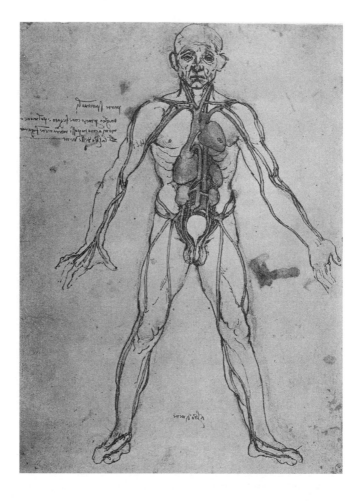

removing the very minutest particles of the flesh by which these veins are surrounded, without causing them to bleed, excepting the insensible bleeding of the capillary veins; and as one single body would not last so long, since it was necessary to proceed with several bodies by degrees, until I came to an end and had a complete knowledge; this I repeated twice, to learn the differences.

And if you should have a love for such things you might be prevented by loathing, and if that did not prevent you, you might be deterred by the fear of living in the night hours in the company of those corpses, quartered and flayed and horrible to see. And if this did not prevent you, perhaps you might not be able to draw so well as is necessary for such a demonstration; or, if you had the skill in drawing, it might not be combined with knowledge of perspective; and if it were so, you might not understand the methods of geo-metrical demonstration and the method of the calculation of forces and of the strength of the muscles; patience also may be wanting, so that you lack perseverance. As to whether all these things were found in me or not, the hundred and twenty books composed by me will give verdict Yes or No. In these I have been hindered neither

by avarice nor negligence, but simply by want of time. Farewell.

∾

This work must begin with the conception of man, and describe the nature of the womb and how the foetus lives in it, up to what stage it resides there, and in what way it quickens into life and feeds. Also its growth and what interval there is between one stage of growth and another. What it is that forces it out from the body of the mother, and for what reasons it sometimes comes out of the mother's womb before the due time.

Then I will describe which are the members, which, after the boy is born, grow more than the others, and determine the proportions of a boy of one year.

Then describe the fully grown man and woman, with their proportions, and the nature of their complexions, colour, and physiognomy.

Then how they are composed of veins, tendons, muscles and bones. This I shall do at the end of the book. Then, in four drawings, represent four universal conditions of men. That is, Mirth, with various acts of laughter, and describe the cause of laughter. Weeping in various aspects with its causes.

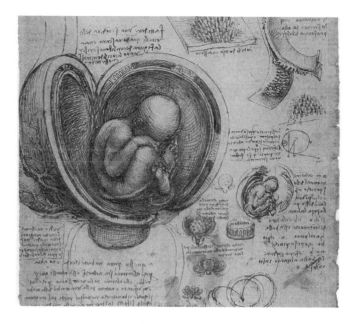

Contention, with various acts of killing; flight, fear, ferocity, boldness, murder and every thing pertaining to such cases. Then represent Labour, with pulling, thrusting, carrying, stopping, supporting and such like things.

Further I would describe attitudes and movements. Then perspective, concerning the functions and effects of the eye; and of hearing – here I will speak of music, and treat of the other senses.

And then describe the nature of the senses.

This mechanism of man we will demonstrate in figures; of which the three first will show the ramification of the bones; that is: first one to show their height and position and shape; the second will be seen in profile and will show the depth of the whole and of the parts, and their position. The third figure will be a demonstration of the bones of the backparts. Then I will make three other figures from the same point of view, with the bones sawn across, in which will be shown their thickness and hollowness. Three other figures of the bones complete, and of the nerves which rise from the nape of the neck, and in what limbs they ramify. And three others of the bones and veins, and where they ramify. Then three figures with the muscles and three with the skin, and their proper proportions; and three of woman, to illustrate the womb and the menstrual veins which go to the breasts.

First draw the bones, let us say, of the arm, and put in the motor muscle from the shoulder to the elbow with all its lines. Then proceed in the same way from the elbow to the wrist. Then from the wrist to the hand and from the hand to the fingers.

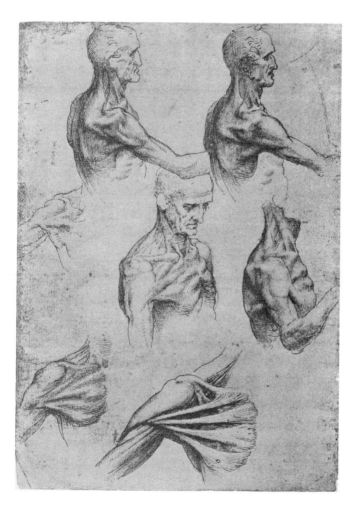

And in the arm you will put the motors of the fingers which open, and these you will show separately in their demonstration. In the second demonstration you will clothe these muscles with the secondary motors of the fingers and so proceed by degrees to avoid confusion. But first lay on the bones those muscles which lie close to the said bones, without confusion of other muscles; and with these you may put the nerves and veins which supply their nourishment, after having first drawn the tree of veins and nerves over the simple bones.

Remember that to be certain of the point of origin of any muscle, you must pull the sinew from which the muscle springs in such a way as to see that muscle move, and where it is attached to the ligaments of the bones.

Which is the part in man, which, as he grows fatter, never gains flesh?

Or what part which, as a man grows lean, never falls away with a too perceptible diminution? And among the parts which grow fat which is that which grows fattest?

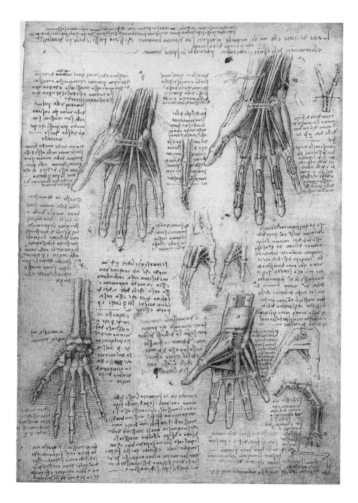

Among those which grow lean which is that which grows leanest?

In very strong men which are the muscles which are thickest and most prominent?

In your anatomy you must represent all the stages of the limbs from man's creation to his death, and then till the death of the bone; and which part of him is first decayed and which is preserved the longest.

And in the same way of extreme leanness and extreme fatness.

❧

There are eleven elementary tissues: – cartilage, bones, nerves, veins, arteries, fascia, ligament and sinews, skin, muscle and fat.

❧

The divisions of the head are 10, viz. 5 external and 5 internal. The external are the hair, skin, muscle, fascia and the skull; the internal are the dura mater, the pia mater, which enclose the brain. The pia mater and the dura mater come again underneath and enclose the brain; then the rete mirabile, and the occipital bones, which supports the brain from which the nerves spring.

∾

The tears come from the heart and not from the brain.

Define all the parts, of which the body is composed, beginning with the skin with its outer cuticle which is often chapped by the influence of the sun.

19

Man compared with animals

✥

Man. The description of man, which includes that of such creatures as are of almost the same species, as Apes, Monkeys and the like, which are many.

The Lion and its kindred, as Panthers. Wildcats, Tigers, Leopards, Wolfs, Lynxes, Spanish cats, common cats and the like.

The Horse and its kindred, as Mule, Ass and the like, with incisor teeth above and below.

The Bull and its allies with horns and without upper incisors as the Buffalo, Stag Fallow Deer, Wild Goat, Swine, Goat, wild Goats, Muskdeers, Chamois, Giraffe.

∿

The walking of man is always after the universal manner of walking in animals with four legs, inasmuch as just as they move their feet crosswise after the manner of a horse in trotting, so man moves

his four limbs crosswise; that is, if he puts forward his right foot in walking he puts forward, with it, his left arm and vice versa, invariably.

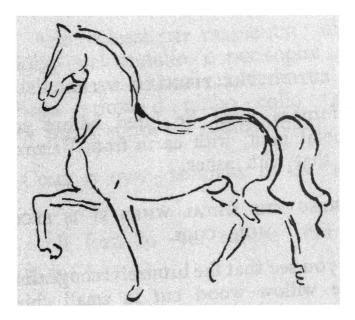

20

Physiology and medicine

✛

I have found that in the composition of the human body as compared with the bodies of animals the organs of sense are duller and coarser. Thus it is composed of less ingenious instruments, and of spaces less capacious for receiving the faculties of sense. I have seen in the Lion tribe that the sense of smell is connected with part of the substance of the brain which comes down the nostrils, which form a spacious receptacle for the sense of smell, which enters by a great number of cartilaginous vesicles with several passages leading up to where the brain, as before said, comes down.

The eyes in the Lion tribe have a large part of the head for their sockets and the optic nerves communicate at once with the brain; but the contrary is to be seen in man, for the sockets of the eyes are but a small part of the head, and the optic nerves are very fine and long and weak, and by the weakness of

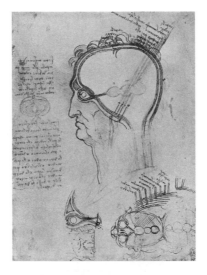

their action we see by day but badly at night, while these animals can see as well at night as by day. The proof that they can see is that they prowl for prey at night and sleep by day, as nocturnal birds do also.

❧

Every object we see will appear larger at midnight than at midday, and larger in the morning than at midday.

This happens because the pupil of the eye is much smaller at midday than at any other time.

In proportion as the eye or the pupil of the owl is larger in proportion to the animal than that of man, so much the more light can it see at night than man can; hence at midday it can see nothing if its pupil does not diminish; and, in the same way, at night things look larger to it than by day.

∽

Sight is better from a distance than near in those men who are advancing in age, because the same object transmits a smaller impression of itself to the eye when it is distant than when it is near.

∽

The Common Sense is that which judges of things offered to it by the other senses. The ancient speculators have concluded that that part of man which constitutes his judgement is caused by a central organ to which the other five senses refer everything by means of impressibility; and to this centre they have given the name Common Sense. And they say that this Sense is situated in the centre of the head between Sensation and Memory. And this name of Common Sense is given to it solely because it is the common judge of all the other five senses i.e. Seeing, Hearing, Touch, Taste and Smell.

This Common Sense is acted upon by means of Sensation which is placed as a medium between it and the senses. Sensation is acted upon by means of the images of things presented to it by the external instruments, that is to say the senses which are the medium between external things and Sensation. In the same way the senses are acted upon by objects. Surrounding things transmit their images to the senses and the senses transfer them to the Sensation. Sensation sends them to the Common Sense, and by it they are stamped upon the memory and are there more or less retained according to the importance or force of the impression. The sense is most rapid in its function which is nearest to the sensitive medium and the eye, being the highest is the chief of the others. Of this then only we will speak, and the others we will leave in order not to make our matter too long. Experience tells us that the eye apprehends ten different natures of things, that is: Light and Darkness (one being the cause of the perception of the nine others, and the other its absence), colour and substance, form and place, distance and nearness, motion and stillness.

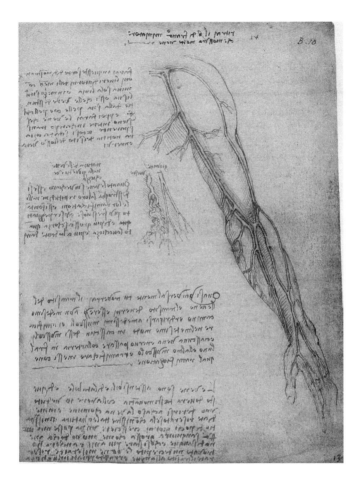

Though human ingenuity may make various inventions which, by the help of various machines, answer to the same end, it will never devise any inventions more beautiful, nor more simple, nor more to the purpose than Nature does; because in her inventions nothing is wanting, and nothing is superfluous, and she needs no counterpoise when she makes limbs proper for motion in the bodies of animals. But she puts into them the soul of the body which forms them, that is the soul of the mother, which first constructs in the womb the form of the man and in due time awakens the soul that is to inhabit it. And this at first lies dormant and under the tutelage of the soul of the mother, who nourishes and vivifies it by the umbilical vein, with all its spiritual parts, and this happens because this umbilicus is joined to the placenta and the cotyledons, by which the child is attached to the mother. And these are the reason why a wish, a strong craving or a fright or any other mental suffering in the mother, has more influence on the child than on the mother; for there are many cases when the child loses its life from them, &c.

This discourse is not in its place here, but will be wanted for the one on the composition of animated bodies – and the rest of the definition of the soul

leave to the imaginations of friars, those fathers of the people who know all secrets by inspiration.

I leave alone the sacred books; for they are supreme truth.

∽

The soul seems to reside in the judgement, and the judgement would seem to be seated in that part where all the senses meet; and this is called the Common Sense and is not all-pervading throughout the body, as many have thought.

∽

There are four Powers: memory and intellect, desire and covetousness. The two first are mental and the others sensual. The three senses: sight, hearing and smell cannot well be prevented; touch and taste not at all. Smell is connected with taste in dogs and other gluttonous animals.

∽

Lust is the cause of generation.

Appetite is the support of life. Fear or timidity is the prolongation of life and preservation of its instruments.

Our life is made by the death of others.

In dead matter insensible life remains, which, reunited to the stomachs of living beings, resumes life, both sensual and intellectual.

Here nature appears with many animals to have been rather a cruel stepmother than a mother, and with others not a stepmother, but a most tender mother.

Man and animals are really the passage and the conduit of food, the sepulchre of animals and resting place of the dead, one causing the death of the other, making themselves the covering for the corruption of other dead bodies.

∽

Death in old men, when not from fever, is caused by the veins which go from the spleen to the valve of the liver, and which thicken so much in the walls that they become closed up and leave no passage for the blood that nourishes it.

The incessant current of the blood through the veins makes these veins thicken and become callous, so that at last they close up and prevent the passage of blood.

∽

The waters return with constant motion from the lowest depths of the sea to the utmost height of the mountains, not obeying the nature of heavier bodies; and in this they resemble the blood of animated beings which always moves from the sea of the heart and flows towards the top of the head; and here it may burst a vein, as may be seen when a vein bursts in the nose; all the blood rises from below to the

level of the burst vein. When the water rushes out from the burst vein in the earth, it obeys the law of other bodies that are heavier than the air since it always seeks low places.

∽

Make them give you the definition and remedies for the case ... and you will see that men are selected to be doctors for diseases they do not know.

∽

To keep in health, this rule is wise: Eat only when you want and relish food. Chew thoroughly that it may do you good. Have it well cooked, unspiced and undisguised. He who takes medicine is ill advised.

21

On astronomy

✜

The earth is not in the centre of the Sun's orbit nor at the centre of the universe, but in the centre of its companion elements, and united with them. And anyone standing on the moon, when it and the sun are both beneath us, would see this our earth and the element of water upon it just as we see the moon, and the earth would light it as it lights us.

∼

Each man is always in the middle of the surface of the earth and under the zenith of his own hemisphere, and over the centre of the earth.

∼

Beyond the sun and us there is darkness and so the air appears blue.

∼

The sun will appear larger in moving water or on waves than in still water; an example is the light reflected on the strings of a monochord.

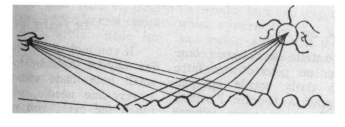

If you look at the stars, cutting off the rays (as may be done by looking through a very small hole made with the extreme point of a very fine needle, placed so as almost to touch the eye), you will see those stars so minute that it would seem as though nothing could be smaller; it is in fact their great distance which is the reason of their diminution, for many of them are very many times larger than the star which is the earth with water.

Take a piece of paper and pierce holes in it with a needle, and look at the sun through these holes.

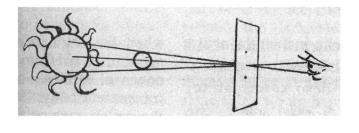

The image of the sun in the moon is powerfully luminous, and is only on a small portion of its surface. And the proof may be seen by taking a ball of burnished gold and placing it in the dark with a light at some distance from it; and then, although it will illuminate about half of the ball, the eye will perceive its reflection only in a small part of its surface, and all the rest of the surface reflects the darkness which surrounds it; so that it is only in that spot that the image of the light is seen, and all the rest remains invisible, the eye being at a distance from the ball. The same thing would happen on the surface of the moon if it were polished, lustrous and opaque, like all bodies with a reflecting surface.

The moon has no light in itself; but so much of it as faces the sun is illuminated, and of that illumined

portion we see so much as faces the earth. And the moon's night receives just as much light as is lent it by our waters as they reflect the image of the sun, which is mirrored in all those waters which are on the side towards the sun.

Cicero says in his book *De Divinatione* that Astrology has been practised since 570,000 years before the Trojan war.

22

Geography

✥

By the ancients man has been called the world in miniature; and certainly this name is well bestowed, because, inasmuch as man is composed of earth, water, air and fire, his body resembles that of the earth; and as man has in him bones [which are] the supports and framework of his flesh, the world has its rocks the supports of the earth; as man has in him a pool of blood in which the lungs rise and fall in breathing, so the body of the earth has its ocean tide which likewise rises and falls every six hours, as if the world breathed; as in that pool of blood veins have their origin, which ramify all over the human body, so likewise the ocean sea fills the body of the earth with infinite springs of water. The body of the earth lacks sinews and this is because the sinews are made expressly for movements and, the world being perpetually stable, no movement takes place, and no movement

taking place, muscles are not necessary. But in all other points they are much alike.

∾

The great elevations of the peaks of the mountains above the sphere of the water may have resulted from this: a very large portion of the earth which was filled with water, that is to say the vast cavern inside the earth may have fallen in a vast part of its vault towards the centre of the earth, being pierced by means of the course of the springs which continually wear away the place where they pass.

Sinking in of countries like the Dead Sea in Syria, that is Sodom and Gomorrah.

It is of necessity that there should be more water than land, and the visible portion of the sea does not show this; so that there must be a great deal of water inside the earth, besides that which rises into the lower air and which flows through rivers and springs.

∾

Pliny says in his second book, chapter 103, that the water of the sea is salt because the heat of the sun dries up the moisture and drinks it up; and this gives to the wide stretching sea the savour of salt. But this

cannot be admitted, because if the saltness of the sea were caused by the heat of the sun, there can be no doubt that lakes, pools and marshes would be so much the more salt, as their waters have less motion and are of less depth; but experience shows us, on the contrary, that these lakes have their waters quite free from salt. Again it is stated by Pliny in the same chapter that this saltness might originate, because all the sweet and subtle portions which the heat attracts easily being taken away, the more bitter and coarser part will remain, and thus the water on the surface is fresher than at the bottom; but this is contradicted by the same reason given above, which is, that the same thing would happen in marshes and other waters, which are dried up by the heat. Again, it has been said that the saltness of the sea is the sweat of the earth; to this it may be answered that all the springs of water which penetrate through the earth would then be salt. But the conclusion is, that the saltness of the sea must proceed from the many springs of water which, as they penetrate into the earth, find mines of salt and these they dissolve in part, and carry with them to the ocean and the other seas, whence the clouds, the begetters of rivers, never carry it up. And the sea would be salter in our times than ever it was at any time; and

if the adversary were to say that in infinite time the sea would dry up or congeal into salt, to this I answer that this salt is restored to the earth by the setting free of that part of the earth which rises out of the sea with the salt it has acquired, and the rivers return it to the earth under the sea.

A wave of the sea always breaks in front of its base, and that portion of the crest will then be lowest which before was highest.

The same cause which stirs the humours in every species of animal body and by which every injury is repaired, also moves the waters from the utmost depth of the sea to the greatest heights.

Here a doubt arises, and that is: whether the deluge, which happened at the time of Noah, was universal or not. And it would seem not, for the reasons now to be given: We have it in the Bible that this deluge lasted 40 days and 40 nights of incessant and universal rain, and that this rain rose to ten cubits above the highest mountains in the world. And if it had been that the rain was universal, it would have covered our globe which is spherical in form. And this spherical surface is equally distant in every part, from the centre of its sphere; hence the sphere of the waters being under the same conditions, it is impossible that the water upon it should move, because water, in itself, does not move unless it falls; therefore how could the waters of such a deluge depart, if it is proved that it has no motion? And if it departed how could it move unless it went upwards? Here, then, natural reasons are wanting; hence to remove this doubt it is necessary to call in a miracle to aid us, or else to say that all this water was evaporated by the heat of the sun.

∽

I say that the deluge could not carry objects native to the sea up to the mountains, unless the sea had already increased so as to create inundations as high

up as those places; and this increase could not have occurred because it would cause a vacuum; and if you were to say that the air would rush in there, we have already concluded that what is heavy cannot remain above what is light, whence of necessity we must conclude that this deluge was caused by rain water, so that all these waters ran to the sea, and the sea did not run up the mountains; and as they ran to the sea, they thrust the shells from the shore of the sea and did not draw them towards themselves.

Why do we find the bones of great fishes and oysters and corals and various other shells and sea-snails on the high summits of mountains by the sea, just as we find them in low seas?

To know better the direction of the winds.

Nothing originates in a spot where there is no sentient, vegetable and rational life; feathers grow upon birds and are changed every year; hairs grow upon animals and are changed every year, excepting some parts, like the hairs of the beard in lions, cats and their like. The grass grows in the fields, and the leaves on the trees, and every year they are, in great part, renewed. So that we might say that the earth has a spirit of growth; that its flesh is the soil, its bones the arrangement and connection of the rocks of which the mountains are composed, its cartilage the tufa, and its blood the springs of water. The pool of blood which lies round the heart is the ocean, and its breathing, and the increase and decrease of the blood in the pulses, is represented in the earth by the flow and ebb of the sea; and the heat of the spirit of the world is the fire which pervades the earth, and the seat of the vegetative soul is in the fires, which in many parts of the earth find vent in baths and mines of sulphur, and in volcanoes, as at Mount Etna in Sicily, and in many other places.

23

Notes on the natural world

✣

The river which is to be turned from one place to another must be coaxed and not treated roughly or with violence; and to do this a sort of floodgate should be made in the river, and then lower down one in front of it and in like manner a third, fourth and fifth, so that the river may discharge itself into the channel given to it, or that by this means it may be diverted from the place it has damaged, as was done in Flanders – as I was told by Niccolò di Forsore.

∽

To heat the water for the stove of the Duchess take four parts of cold water to three parts of hot water.

∽

Above the lake of Como towards Germany is the valley of Chiavenna where the river Mera flows into

this lake. Here are barren and very high mountains, with huge rocks. Among these mountains are to be found the water-birds called gulls. Here grow fir trees, larches and pines. Deer, wild-goats, chamois, and terrible bears. It is impossible to climb them without using hands and feet. The peasants go there at the time of the snows with great snares to make the bears fall down these rocks. These mountains which very closely approach each other are parted by the river. They are to the right and left for the distance of 20 miles throughout of the same nature. From mile to mile there are good inns. Above on

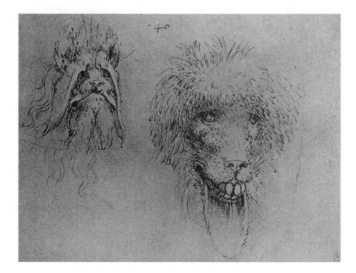

the said river there are waterfalls of 400 braccia in height, which are fine to see; and there is good living at 4 soldi the reckoning. This river brings down a great deal of timber.

∾

On the tops and sides of hills foreshorten the shape of the ground and its divisions, but give its proper shape to what is turned towards you.

∾

From the shore of the Southern coast of Cilicia may be seen to the South the beautiful island of Cyprus, which was the realm of the goddess Venus, and many navigators being attracted by her beauty had their ships and rigging broken amidst the reefs, surrounded by the whirling waters. Here the beauty of delightful hills tempts wandering mariners to refresh themselves amidst their flowery verdure, where the winds are tempered and fill the island and the surrounding seas with fragrant odours. Ah! how many a ship has here been sunk. Ah! how many a vessel broken on these rocks. Here might be seen barks without number, some wrecked and half covered by the sand; others showing the poop and another the prow, here a keel and there the ribs;

and it seems like a day of judgement when there should be a resurrection of dead ships, so great is the number of them covering all the Northern shore; and while the North gale makes various and fearful noises there.

∾

Men born in hot countries love the night because it refreshes them and have a horror of light because it burns them; and therefore they are of the colour of night, that is black. And in cold countries it is just the contrary.

24

Machines and warfare

✤

The way in which the Germans closing up together cross and interweave their broad leather shields against the enemy, stooping down and putting one of the ends on the ground while they hold the rest in their hand.

∾

The Germans are wont to annoy a garrison with the smoke of feathers, sulphur and realgar, and they make this smoke last 7 or 8 hours. Likewise the husks of wheat make a great and lasting smoke; and also dry dung; but this must be mixed with olive husks, that is olives pressed for oil and from which the oil has been extracted.

∾

By means of a certain machine many people may stay some time under water. I do not describe my

method of remaining under water, or how long I can stay without eating; and I do not publish nor divulge these by reason of the evil nature of men, who would use them for assassinations at the bottom of the sea, by sending ships to the bottom, and sinking them together with the men in them. And although I will impart others, there is no danger in them; because the mouth of the tube, by which you breathe, is above the water, supported on bags or corks.

∾

Supposing in a battle between ships and galleys that the ships are victorious by reason of the height of their tops, you must haul the yard up almost to the top of the mast, and at the extremity of the yard, that is the end which is turned towards the enemy, have a small cage fastened, wrapped up below and

all round in a great mattress full of cotton so that
it may not be injured by the bombs; then, with the
capstan, haul down the opposite end of this yard and
the top on the opposite side will go up so high that
it will be far above the round-top of the ship, and
you will easily drive out the men that are in it. But
it is necessary that the men who are in the galley
should go to the opposite side of it so as to afford
a counterpoise to the weight of the men placed
inside the cage on the yard.

Have a coat made of leather, which must be double
across the breast, that is having a hem on each side
of about a finger breadth. Thus it will be double
from the waist to the knee; and the leather must be
quite air-tight. When you want to leap into the sea,
blow out the skirt of your coat through the double
hems of the breast; and jump into the sea, and allow

yourself to be carried by the waves; when you see no shore near, give your attention to the sea you are in, and always keep in your mouth the air-tube which leads down into the coat; and if now and again you require to take a breath of fresh air, and the foam prevents you, you may draw a breath of the air within the coat.

Man when flying must stand free from the waist upwards so as to be able to balance himself as he does in a boat so that the centre of gravity in himself and in the machine may counter-balance each other, and be shifted as necessity demands for the changes of its centre of resistance.

Remember that your flying machine must imitate no other than the bat, because the web is what by its union gives the armour, or strength to the wings.

If you imitate the wings of feathered birds, you will find a much stronger structure, because they are

pervious; that is, their feathers are separate and the air passes through them. But the bat is aided by the web that connects the whole and is not pervious.

∾

Destruction to such a machine may occur in two ways; of which the first is the breaking of the machine. The second would be when the machine should turn on its edge or nearly on its edge, because it ought always to descend in a highly oblique direction, and almost exactly balanced on its centre. As regards the first – the breaking of the machine – that may be prevented by making it as strong as possible; and in whichever direction it may tend to turn over, one centre must be very far from the other; that is, in a machine 30 braccia long the centres must be 4 braccia one from the other.

∾

If you want to know where a mine runs, place a drum over all the places where you suspect that it is being made, and upon this drum put a couple of dice, and when you are over the spot where they are mining, the dice will jump a little on the drum at every blow which is given underground in the mining.

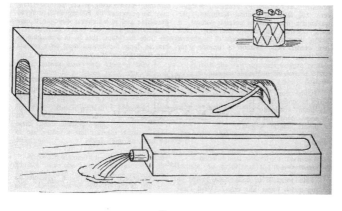

Take charcoal of willow, and saltpetre, and sulphuric acid, and sulphur, and pitch, with frankincense and camphor, and Ethiopian wool, and boil them all together. This fire is so ready to burn that it clings to the timbers even under water. And add to this composition liquid varnish, and bituminous oil, and turpentine and strong vinegar, and mix all together and dry it in the sun, or in an oven when the bread is taken out; and then stick it round hempen or other tow, moulding it into a round form, and studding it all over with very sharp nails. You must leave in this ball an opening to serve as a fusee, and cover it with rosin and sulphur.

Again, this fire, stuck at the top of a long plank which has one braccio length of the end pointed with iron that it may not be burnt by the said fire, is good for avoiding and keeping off the ships, so as not to be overwhelmed by their onset.

Again throw vessels of glass full of pitch on to the enemy's ships when the men in them are intent on the battle; and then by throwing similar burning balls upon them you have it in your power to burn all their ships.

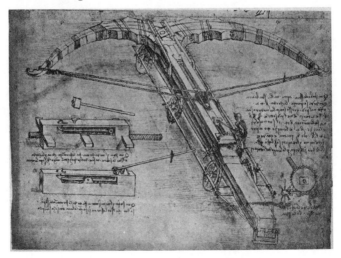

25

Number tricks

＊

Take in each hand an equal number; put 4 from the
right hand into the left; cast away the remainder;
cast away an equal number from the left hand; add
5, and now you will find 13 in this left hand; that is
– I made you put 4 from the right hand into the left,
and cast away the remainder; now your right hand
has 4 more; then I make you throw away as many
from the right as you threw away from the left;
so, throwing from each hand a quantity of which
the remainder may be equal, you now have 4 and
4, which make 8, and that the trick may not be
detected I made you put 5 more, which made 13.

∽

Take any number less than 12 that you please; then
take of mine enough to make up the number 12, and
that which remains to me is the number which you
at first had; because when I said, take any number

less than 12 as you please, I took 12 into my hand, and of that 12 you took such a number as made up your number of 12; and what you added to your number, you took from mine; that is, if you had 8 to go as far as to 12, you took of my 12, 4; hence this 4 transferred from me to you reduced my 12 to a remainder of 8, and your 8 became 12; so that my 8 is equal to your 8, before it was made 12.

26

Philosophical maxims

✢

I obey thee Lord, first for the love I ought, in all reason to bear Thee; secondly for that Thou canst shorten or prolong the lives of men.

෴

Thou, O God, dost sell us all good things at the price of labour.

෴

Necessity is the mistress and guide of nature.

Necessity is the theme and the inventress, the eternal curb and law of nature.

෴

The motive power is the cause of all life.

෴

And you, O Man, who will discern in this work of mine the wonderful works of Nature, if you think it would be a criminal thing to destroy it, reflect how much more criminal it is to take the life of a man; and if this, his external form, appears to thee marvellously constructed, remember that it is nothing as compared with the soul that dwells in that structure; for that indeed, be it what it may, is a thing divine. Leave it then to dwell in His work at His good will and pleasure, and let not your rage or malice destroy a life – for indeed, he who does not value it, does not himself deserve it.

Why does the eye see a thing more clearly in dreams than with the imagination being awake?

The senses are of the earth; Reason stands apart in contemplation.

Science is the observation of things possible, whether present or past; prescience is the knowledge of things which may come to pass, though but slowly.

∾

Experience, the interpreter between formative nature and the human race, teaches how that nature acts among mortals; and being constrained by necessity cannot act otherwise than as reason, which is its helm, requires her to act.

∾

Wisdom is the daughter of experience.

∾

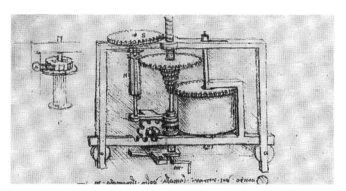

Instrumental or mechanical science is of all the noblest and the most useful, seeing that by means of this all animated bodies that have movement perform all their actions; and these movements are based on the centre of gravity which is placed in the middle dividing unequal weights, and it has

dearth and wealth of muscles and also lever and counter-lever.

❦

Mechanics are the Paradise of mathematical science, because here we come to the fruits of mathematics.

❦

Every instrument requires to be made by experience.

❦

The man who blames the supreme certainty of mathematics feeds on confusion, and can never silence the contradictions of sophistical sciences which lead to an eternal quackery.

❦

There is no certainty in sciences where one of the mathematical sciences cannot be applied, or which are not in relation with these mathematics.

❦

Science is the captain, and practice the soldiers.

❧

Those who fall in love with practice without science are like a sailor who enters a ship without a helm or a compass, and who never can be certain whither he is going.

27

Moral sayings

✤

O Time! consumer of all things; O envious age! thou dost destroy all things and devour all things with the relentless teeth of years, little by little in a slow death. Helen, when she looked in her mirror, seeing the withered wrinkles made in her face by old age, wept and wondered why she had twice been carried away.

O Time! consumer of all things, and O envious age! by which all things are all devoured.

⌒

Every evil leaves behind a grief in our memory, except the supreme evil, that is death, which destroys this memory together with life.

⌒

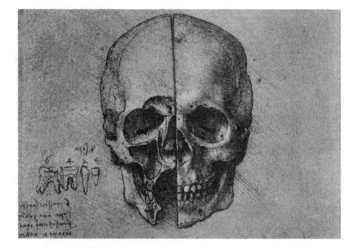

The knowledge of past times and of the places on the earth is both an ornament and nutriment to the human mind.

⌒

To lie is so vile, that even if were in speaking well of godly things it would take off something from God's grace; and Truth is so excellent, that if it praises but small things they become noble.

Beyond a doubt truth bears the same relation to falsehood as light to darkness; and this truth is in itself so excellent that, even when it dwells on humble and lowly matters, it is still infinitely above

uncertainty and lies, disguised in high and lofty discourses; because in our minds, even if lying should be their fifth element, this does not prevent that the truth of things is the chief nutriment of superior intellects, though not of wandering wits.

But you who live in dreams are better pleased by the sophistical reasons and frauds of wits in great and uncertain things, than by those reasons which are certain and natural and not so far above us.

Avoid studies of which the result dies with the worker.

Men are in error when they lament the flight of time, accusing it of being too swift, and not perceiving that it is sufficient as it passes; but good memory, with which nature has endowed us, causes things long past to seem present.

Learning acquired in youth arrests the evil of old age; and if you understand that old age has wisdom for its food, you will so conduct yourself in youth that your old age will not lack for nourishment.

❧

The acquisition of any knowledge is always of use to the intellect, because it may thus drive out useless things and retain the good.

For nothing can be loved or hated unless it is first known.

❧

As a day well spent procures a happy sleep, so a life well employed procures a happy death.

❧

The water you touch in a river is the last of that which has passed, and the first of that which is coming. Thus it is with time present.

Life if well spent, is long.

❧

Just as food eaten without caring for it is turned into loathsome nourishment, so study without a taste for it spoils memory, by retaining nothing which it has taken in.

❧

On Mount Etna the words freeze in your mouth and you may make ice of them.

Just as iron rusts unless it is used, and water putrifies or, in cold, turns to ice, so our intellect spoils unless it is kept in use.

You do ill if you praise, and still worse if you reprove in a matter you do not understand.

When Fortune comes, seize her in front with a sure hand, because behind she is bald.

❧

Some there are who are nothing else than a passage for food and augmentors of excrement and fillers of privies, because through them no other things in the world, nor any good effects are produced, since nothing but full privies results from them.

❧

The greatest deception men suffer is from their own opinions.

❧

That is not riches, which may be lost; virtue is our true good and the true reward of its possessor. That cannot be lost; that never deserts us, but when life leaves us. As to property and external riches, hold them with trembling; they often leave their possessor in contempt, and mocked at for having lost them.

He who possesses most must be most afraid of loss.

He who wishes to be rich in a day will be hanged in a year.

The man is of supreme folly who always wants for fear of wanting; and his life flies away while he is still hoping to enjoy the good things which he has with extreme labour acquired.

Ask counsel of him who rules himself well.

Justice requires power, insight, and will; and it resembles the queen-bee.

He who does not punish evil commands it to be done.

He who takes the snake by the tail will presently be bitten by it.

The grave will fall in upon him who digs it.

The man who does not restrain wantonness, allies himself with beasts.

You can have no dominion greater or less than that over yourself.

He who thinks little, errs much.

It is easier to contend with evil at the first than at the last.

No counsel is more loyal than that given on ships which are in peril; he may expect loss who acts on the advice of an inexperienced youth.

∾

To speak well of a base man is much the same as speaking ill of a good man.

Envy wounds with false accusations, that is with detraction, a thing which scares virtue.

Fear arises sooner than anything else.

Words which do not satisfy the ear of the hearer weary him or vex him, and the symptoms of this you will often see in such hearers in their frequent yawns; you therefore, who speak before men whose good will you desire, when you see such an excess of fatigue, abridge your speech, or change your discourse; and if you do otherwise, then instead of the favour you desire, you will get dislike and hostility.

And if you would see in what a man takes pleasure, without hearing him speak, change the subject of your discourse in talking to him, and when you presently see him intent, without yawning or wrinkling his brow or other actions of various kinds, you may be certain that the matter of which you are speaking is such as is agreeable to him &c.

The lover is moved by the beloved object as the senses are by sensible objects; and they unite and become one and the same thing. The work is the first thing born of this union; if the thing loved is base the lover becomes base.

When the thing taken into union is perfectly adapted to that which receives it, the result is delight and pleasure and satisfaction.

When that which loves is united to the thing beloved it can rest there; when the burden is laid down it finds rest there.

28

Polemics

✠

O speculators on things, boast not of knowing the things that nature ordinarily brings about; but rejoice if you know the end of those things which you yourself devise.

∽

O speculators on perpetual motion, how many vain projects of the like character you have created! Go and be the companions of the searchers for gold.

∽

The false interpreters of nature declare that quick-silver is the common seed of every metal, not remembering that nature varies the seed according to the variety of the things she desires to produce in the world.

∽

And many have made a trade of delusions and false miracles, deceiving the stupid multitude.

∾

Abbreviators do harm to knowledge and to love, seeing that the love of any thing is the offspring of this knowledge, the love being the more fervent in proportion as the knowledge is more certain. And this certainty is born of a complete knowledge of all the parts, which, when combined, compose the totality of the thing which ought to be loved. Of what use then is he who abridges the details of those matters of which he professes to give thorough information, while he leaves behind the chief part of the things of which the whole is composed? It is true that impatience, the mother of stupidity, praises brevity, as if such persons had not life long enough to serve them to acquire a complete knowledge of one single subject, such as the human body; and then they want to comprehend the mind of God in which the universe is included, weighing it minutely and mincing it into infinite parts, as if they had to dissect it!

O human stupidity, do you not perceive that, though you have been with yourself all your life, you are not yet aware of the thing you possess

most of, that is of your folly? and then, with the crowd of sophists, you deceive yourselves and others, despising the mathematical sciences, in which truth dwells and the knowledge of the things included in them. And then you occupy yourself with miracles, and write that you possess information of those things of which the human mind is incapable and which cannot be proved by any instance from nature. And you fancy you have wrought miracles when you spoil a work of some speculative mind, and do not perceive that you are falling into the same error as that of a man who strips a tree of the ornament of its branches covered with leaves mingled with the scented blossoms or fruit, as Justinus did, in abridging the histories written by Trogus Pompeius, who had written in an ornate style all the worthy deeds of his forefathers, full of the most admirable and ornamental passages; and so composed a bald work worthy only of those impatient spirits, who fancy they are losing as much time as that which they employ usefully in studying the works of nature and the deeds of men. But these may remain in company of beasts; among their associates should be dogs and other animals full of rapine and they may hunt

with them after, and then follow helpless beasts, which in time of great snows come near to your houses asking alms as from their master.

◦~◦

O mathematicians, shed light on this error.

The spirit has no voice, because where there is a voice there is a body, and where there is a body space is occupied, and this prevents the eye from seeing what is placed behind that space; hence the surrounding air is filled by the body, that is by its image.

◦~◦

There can be no voice where there is no motion or percussion of the air; there can be no percussion of the air where there is no instrument, there can be no instrument without a body; and this being so, a spirit can have neither voice, nor form, nor strength. And if it were to assume a body it could not penetrate nor enter where the passages are closed. And if anyone should say that by air, compressed and compacted together, a spirit may take bodies of various forms and by this means speak and move with strength – to him I reply that when there are neither nerves nor bones there can be no

force exercised in any kind of movement made by such imaginary spirits.

Beware of the teaching of these specula-tors, because their reasoning is not confirmed by experience.

❧

Of all human opinions that are to be reputed the most foolish is that which deals with the belief in Necromancy, the sister of Alchemy, which gives birth to simple and natural things. But it is all the more worthy of reprehension than alchemy, because it brings forth nothing but what is like itself, that is, lies; this does not happen in Alchemy which deals with simple products of nature and whose function cannot be exercised by nature itself, because it has no organic instruments with which it can work, as men do by means of their hands, who have produced, for instance, glass &c. But this Necromancy the flag and flying banner, blown by the winds, is the guide of the stupid crowd which is constantly witness to the dazzling and endless effects of this art; and there are books full, declaring that enchantments and spirits can work and speak without tongues and without organic instruments – without which it is impos-sible to speak – and can carry heaviest weights and

raise storms and rain; and that men can be turned into cats and wolves and other beasts, although indeed it is those who affirm these things who first became beasts.

And surely if this Necromancy did exist, as is believed by small wits, there is nothing on the earth that would be of so much importance alike for the detriment and service of men, if it were true that there were in such an art a power to disturb the calm serenity of the air, converting it into darkness and making coruscations or winds, with terrific thunder and lightnings rushing through the darkness, and with violent storms overthrowing high buildings and rooting up forests, and thus to oppose armies, crushing and annihilating them; and, besides these frightful storms may deprive the peasants of the reward of their labours. Now what kind of warfare is there to hurt the enemy so much as to deprive him of the harvest? What naval warfare could be compared with this? I say, the man who has power to command the winds and to make ruinous gales by which any fleet may be submerged – surely a man who could command such violent forces would be lord of the nations, and no human ingenuity could resist his crushing force. The hidden treasures and gems reposing in the body of the earth would all

be made manifest to him. No lock nor fortress, though impregnable, would be able to save anyone against the will of the necromancer. He would have himself carried through the air from East to West and through all the opposite sides of the universe. But why should I enlarge further upon this? What is there that could not be done by such a craftsman? Almost nothing, except to escape death. Hereby I have explained in part the mischief and the usefulness, contained in this art, if it is real; and if it is real why has it not remained among men who desire it so much, having nothing to do with any deity? For I know that there are numberless people who would, to satisfy a whim, destroy God and all the universe; and if this necromancy, being, as it were, so necessary to men, has not been left among them, it can never have existed, nor will it ever exist according to the definition of the spirit, which is invisible in substance; for within the elements there are no incorporate things, because where there is no body, there is a vacuum; and no vacuum can exist in the elements because it would be immediately filled up.

∽

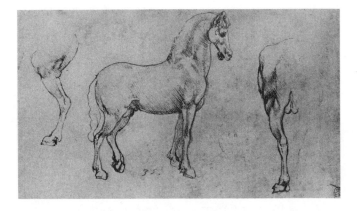

Why did nature not ordain that one animal should not live by the death of another? Nature, being inconstant and taking pleasure in creating and making constantly new lives and forms, because she knows that her terrestrial materials become thereby augmented, is more ready and more swift in her creating than time in his destruction; and so she has ordained that many animals shall be food for others. Nay, this not satisfying her desire, to the same end she frequently sends forth certain poisonous and pestilential vapours upon the vast increase and congregation of animals; and most of all upon men, who increase vastly because other animals do not feed upon them; and, the causes being removed, the effects would not follow. This earth therefore seeks

to lose its life, desiring only continual reproduction; and as, by the argument you bring forward and demonstrate, like effects always follow like causes, animals are the image of the world.

29

Studies on the life and habits of animals

✛

The goldfinch is a bird of which it is related that, when it is carried into the presence of a sick person, if the sick man is going to die, the bird turns away its head and never looks at him; but if the sick man is to be saved the bird never loses sight of him but is the cause of curing him of all his sickness.

Like unto this is the love of virtue. It never looks at any vile or base thing, but rather clings always to pure and virtuous things and takes up its abode in a noble heart; as the birds do in green woods on flowery branches. And this Love shows itself more in adversity than in prosperity; as light does, which shines most where the place is darkest.

∽

We read of the kite that, when it sees its young ones growing too big in the nest, out of envy it pecks their sides, and keeps them without food.

Sadness resembles the raven, which, when it sees its young ones born white, departs in great grief, and abandons them with doleful lamentations, and does not feed them until it sees in them some few black feathers.

We read of the beaver that when it is pursued, knowing that it is for the virtue contained in its medicinal testicles and not being able to escape, it stops; and to be at peace with its pursuers, it bites off its testicles with its sharp teeth, and leaves them to its enemies.

It is said of the bear that when he goes to the haunts of bees to take their honey, the bees having begun to sting him he leaves the honey and rushes to revenge himself. And as he seeks to be revenged on all those that sting him, he is revenged on none; in such ways that his rage is turned to madness, and he flings himself on the ground, vainly exasperating, by his hands and feet, the foes against which he is defending himself.

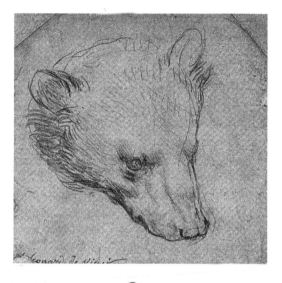

Pigeons are a symbol of ingratitude; for when they are old enough no longer to need to be fed, they begin to fight with their father, and this struggle does not end until the young one drives the father out and takes the hen and makes her his own.

When the wolf goes cunningly round some stable of cattle, and by accident puts his foot in a trap, so that he makes a noise, he bites his foot off to punish himself for his folly.

Although partridges steal each other's eggs, nevertheless the young born of these eggs always return to their true mother.

The fox when it sees a flock of herons or magpies or birds of that kind, suddenly flings himself on the ground with his mouth open to look as he were dead; and these birds want to peck at his tongue, and he bites off their heads.

As regards this vice of vainglory, we read that the peacock is more guilty of it than any other animal. For it is always contemplating the beauty of its tail, which it spreads in the form of a wheel, and by its cries attracts to itself the gaze of the creatures that surround it.

And this is the last vice to be conquered.

The camel is the most lustful animal there is, and will follow the female for a thousand miles. But if you keep it constantly with its mother or sister it will leave them alone, so temperate is its nature.

⌒

The unicorn, through its intemperance and not knowing how to control itself, for the love it bears to fair maidens forgets its ferocity and wildness; and laying aside all fear it will go up to a seated damsel and go to sleep in her lap, and thus the hunters take it.

⌒

The falcon, by reason of its haughtiness and pride, is fain to lord it and rule over all the other birds of prey, and longs to be sole and supreme; and very often the falcon has been seen to assault the eagle, the Queen of birds.

⌒

The vulture is so addicted to gluttony that it will go a thousand miles to eat a carcase; therefore is it that it follows armies.

⌒

The bat, owing to unbridled lust, observes no universal rule in pairing, but males with males and females with females pair promiscuously, as it may happen.

This animal catches a man and straightway kills him; after he is dead, it weeps for him with a lamentable voice and many tears. Then, having done lamenting, it cruelly devours him. It is thus with the hypocrite, who, for the smallest matter, has his face bathed with tears, but shows the heart of a tiger and rejoices in his heart at the woes of others, while wearing a pitiful face.

The Bactrian camel has two humps; the Arabian one only. They are swift in battle and most useful to carry burdens. This animal is extremely observant of rule and measure, for it will not move if it has a greater weight than it is used to, and if it is taken too far it does the same, and suddenly stops and so the merchants are obliged to lodge there.

The panther after its bowels have fallen out will still fight with the dogs and hunters.

30

Fables

✥

A dog, lying asleep on the fur of a sheep, one of his fleas, perceiving the odour of the greasy wool, judged that this must be a land of better living, and also more secure from the teeth and nails of the dog than where he fed on the dog; and without farther reflection he left the dog and went into the thick wool. There he began with great labour to try to pass among the roots of the hairs; but after much sweating had to give up the task as vain, because these hairs were so close that they almost touched each other, and there was no space where fleas could taste the skin. Hence, after much labour and fatigue, he began to wish to return to his dog, who however had already departed; so he was constrained after long repentance and bitter tears, to die of hunger.

∽

The monkey, finding a nest of small birds, went up to it greatly delighted. But they, being already fledged, he could only succeed in taking the smallest; greatly delighted he took it in his hand and went to his abode; and having begun to look at the little bird he took to kissing it, and from excess of love he kissed it so much and turned it about and squeezed it till he killed it. This is said for those who by not punishing their children let them come to mischief.

❧

The water, finding that its element was the lordly ocean, was seized with a desire to rise above the air, and being encouraged by the element of fire and rising as a very subtle vapour, it seemed as though it were really as thin as air. But having risen very high, it reached the air that was still more rare and cold, where the fire forsook it, and the minute particles, being brought together, united and became heavy; whence its haughtiness deserting it, it betook itself to flight and it fell from the sky, and was drunk up by the dry earth, where, being imprisoned for a long time, it did penance for its sin.

❧

The razor, having one day come forth from the handle which serves as its sheath and having placed himself in the sun, saw the sun reflected in his body, which filled him with great pride. And turning it over in his thoughts he began to say to himself: 'And shall I return again to that shop from which I have just come? Certainly not; such splendid beauty shall not, please God, be turned to such base uses. What folly it would be that could lead me to shave the lathered beards of rustic peasants and perform such menial service! Is this body destined for such work? Certainly not. I will hide myself in some retired spot and there pass my life in tranquil repose.' And having thus remained hidden for some months, one day he came out into the air, and issuing from his sheath, saw himself turned to the similitude of a rusty saw while his surface no longer reflected the resplendent sun. With useless repentance he vainly deplored the irreparable mischief, saying to himself: 'Oh! how far better was it to employ at the barber's my lost edge of such exquisite keenness! Where is that lustrous surface? It has been consumed by this vexatious and unsightly rust.'

The same thing happens to those minds which instead of exercise give themselves up to sloth. They are like the razor here spoken of, and lose the

keenness of their edge, while the rust of ignorance spoils their form.

∾

A stone of some size recently uncovered by the water lay on a certain spot somewhat raised, and just where a delightful grove ended by a stony road; here it was surrounded by plants decorated by various flowers of diverse colours. And as it saw the great quantity of stones collected together in the roadway below, it began to wish it could let itself fall down there, saying to itself: 'What have I to do here with these plants? I want to live in the company of those, my sisters.' And letting itself fall, its rapid course ended among these longed-for companions. When it had been there some time it began to find itself constantly toiling under the wheels of the carts, the iron-shoed feet of horses and of travellers. This one rolled it over, that one trod upon it; sometimes it lifted itself a little and then it was covered with mud or the dung of some animals, and it was in vain that it looked at the spot whence it had come as a place of solitude and tranquillity.

Thus it happens to those who choose to leave a life of solitary contemplation, and come to live in cities among people full of infinite evil.

31

Jests and tales

✣

A priest, making the rounds of his parish on Easter Eve, and sprinkling holy water in the houses as is customary, came to a painter's room, where he sprinkled the water on some of his pictures. The painter turned round, somewhat angered, and asked him why this sprinkling had been bestowed on his pictures; then said the priest that it was the custom and his duty to do so, and that he was doing good; and that he who did good might look for good in return, and, indeed, for better, since God had promised that every good deed that was done on earth should be rewarded a hundred-fold from above. Then the painter, waiting till he went out, went to an upper window and flung a large pail of water on the priest's back, saying: 'Here is the reward a hundred-fold from above, which you said would come from the good you had done me with

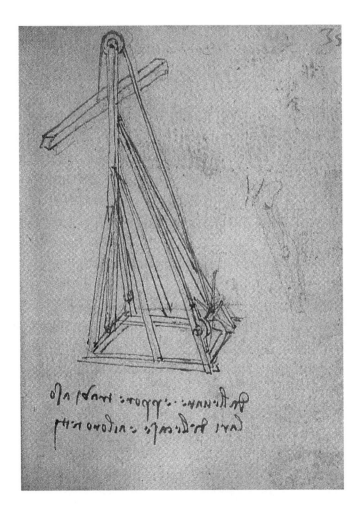

your holy water, by which you have damaged my pictures.'

∽

An old man was publicly casting contempt on a young one, and boldly showing that he did not fear him; on which the young man replied that his advanced age served him better as a shield than either his tongue or his strength.

∽

A man was desired to rise from bed, because the sun was already risen. To which he replied: 'If I had as far to go, and as much to do as he has, I should be risen by now; but having but a little way to go, I shall not rise yet.'

32

Prophecies

✣

Men will seem to see new destructions in the sky. The flames that fall from it will seem to rise in it and to fly from it with terror. They will hear every kind of animal speak in human language. They will instantaneously run in person in various parts of the world, without motion. They will see the greatest splendour in the midst of darkness. O! marvel of the human race! What madness has led you thus! You will speak with animals of every species and they with you in human speech. You will see yourself fall from great heights without any harm and torrents will accompany you, and will mingle with their rapid course.

∾

Of Christians: Many who hold the faith of the Son only build temples in the name of the Mother.

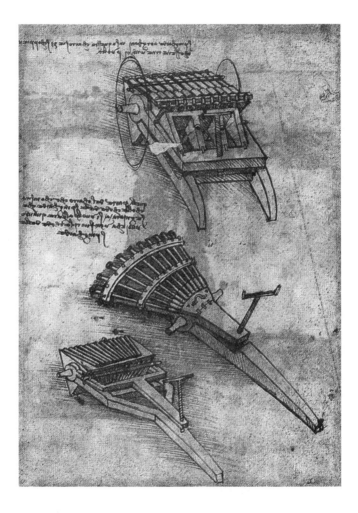

Of flagellants: Men will hide themselves under the bark of trees, and, screaming, they will make themselves martyrs, by striking their own limbs.

Of swords and spears, which by themselves never hurt anyone: One who by himself is mild enough and void of all offence will become terrible and fierce by being in bad company, and will most cruelly take the life of many men, and would kill many more if they were not hindered by bodies having no soul, that have come out of caverns – that is, breastplates of iron.

Of oxen, which are eaten: The masters of estates will eat their own labourers.

Of asses: The severest labour will be repaid with hunger and thirst, and discomfort, and blows, and goadings, and curses, and great abuse.

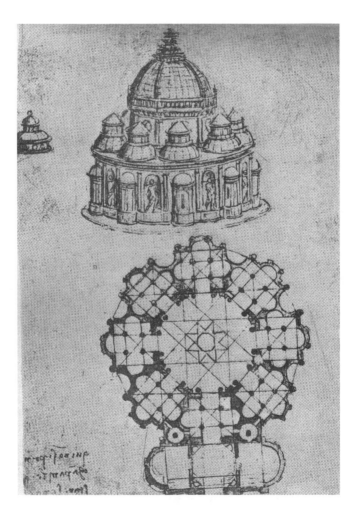

Of writing Letters from one Country to another:
Men will speak with each other from the most
remote countries, and reply.

Of Churches and the Habitations of Friars: Many
will there be who will give up work and labour and
poverty of life and goods, and will go to live among
wealth in splendid buildings, declaring that this is
the way to make themselves acceptable to God.

Of Selling Paradise: An infinite number of men
will sell publicly and unhindered things of the very
highest price, without leave from the Master of it;
while it never was theirs nor in their power; and
human justice will not prevent it.

Of Trees, which nourish grafted shoots: Fathers and
mothers will be seen to take much more delight in
their step-children then in their own children.

The goldfinch gives victuals to its caged young,
Death rather than loss of liberty.

Of Bees: They live together in communities, they are destroyed that we may take the honey from them. Many and very great nations will be destroyed in their own dwellings.

The dog has a horror of the poor, because they eat poor food, and it loves the rich, because they have good living and especially meat. And the excrement of animals always retains some virtue of its origin as is shown by the faeces.

Now dogs have so keen a smell, that they can discern by their nose the virtue remaining in these faeces, and if they find them in the streets, smell

them and if they smell in them the virtue of meat or of other things, they take them, and if not, they leave them: And to return to the question, I say that if by means of this smell they know that dog to be well fed, they respect him, because they judge that he has a powerful and rich master; and if they discover no such smell with the virtue of meat, they judge that dog to be of small account and to have a poor and humble master, and therefore they bite that dog as they would his master.